IMAGES
of America

The CATAWBA
INDIAN NATION
of the Carolinas

Samuel Beck is the inspiration for this *Images of America* volume. He follows in his father's footsteps as secretary/treasurer of the Catawba Nation. He was elected to this post on September 17, 2002. He is worthy of emulation by virtue of his work ethic, his friendly attitude, and his willingness to help others in every way he can.

IMAGES of America
The CATAWBA INDIAN NATION of the Carolinas

Thomas Blumer

Copyright © 2004 by Thomas Blumer
ISBN 978-0-7385-1706-3

Published by Arcadia Publishing
Charleston, South Carolina

Printed in the United States of America

Library of Congress Catalog Card Number: 2004108245

For all general information contact Arcadia Publishing at:
Telephone 843-853-2070
Fax 843-853-0044
E-mail sales@arcadiapublishing.com
For customer service and orders:
Toll-Free 1-888-313-2665

Visit us on the Internet at www.arcadiapublishing.com

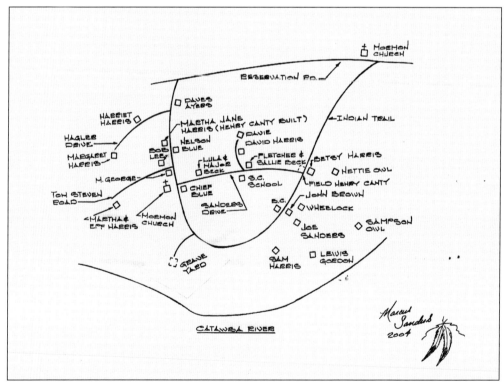

This is a copy of the earliest map drawn of the Catawba Nation combined with notes provided by Georgia Harris and Doris Blue. Both of these ladies were born early in the 20th century and spent a lifetime on the reservation. Key structures of the early 20th century, many of them log cabins, are marked with the names of their primary inhabitants. The only public areas at that time were the grave yard and the church. (Drawing by Marcus Sanders.)

Contents

Acknowledgments		6
Introduction		7
1.	First Photos	9
2.	The Old Reservation	15
3.	Personalities	35
4.	The Western Catawba	51
5.	The Catawba Culture and Its Revival	65
6.	New Reservation	83
7.	Catawba Potters' Hall of Fame	95
8.	The Catawba Indian Nation Progress	109
9.	Catawba Indian Pottery	121

Acknowledgments

This volume is the result of many years of working with the Catawba people. It is difficult to acknowledge individuals when so many people have befriended me and provided me with information. I must mention three of my late mentors: Doris Blue, Nola Campbell, and Georgia Harris. Doris Blue was first on the list, for I met her in 1970. Georgia Harris was second and helped from 1976 until her death. Nola Campbell was an artist of great talent and a friend for many years. I miss all three some every day.

Those Catawba Indians who gave immediate input for *Images of America: The Catawba Indian Nation of the Carolinas* include Michele Garcia Atkinson, Joann George Bauer, Helen Canty Beck, Sam Beck, Anna Brown, Keith Brown, Donna Brown Bruce, Deborah Harris Crisco, Faye Dodds, David Garce, Betty Garcia, Howard George, Susan George, Wayne George, Melvin Harris, Teresa Harris, Wayne Head, Judy Canty Martin, Billie Ann Canty McKellar, Della Harris Oxendine, Earl Robbins, Margaret Robbins, Viola Robbins, Brian Sanders, Caroleen Sanders, Cheryl Harris Sanders, E. Fred Sanders, Marcus Sanders, Roger Trimnal, Bruce Wade, Cynthia Walsh, and Phyllis Beck Williams. All of these people were important to this volume, encouraging me and providing photographs from family albums and crucial facts as I scrambled frantically to find bits of information.

Those non-Indians, often whites who are affiliated with the tribe and academics, cannot be left out of my note of appreciation. Some have been friends to me for many years. The list includes the following: Susan Beck; Dennis Bryson; Gene Crediford, retired from the University of South Carolina; Phillip Crisco; Rob Cox of the American Philosophical Society; R.P.S. Davis of the University of North Carolina; Michael Eldridge of the Schiele Museum; Rev. Kenneth Fugate of Red Path Baptist Church; Jayne Harris; Brent L. Kendrick; Alan May of the Schiele Museum; Steve McKellar; Daisy Njoku of the Smithsonian Institution; Lindsay Pettus; Bill Price; Lou Stancari of the National Museum of the American Indian; Ann Tippitt of the Schiele Museum; and Melissa and Pat Zerance.

These are all the people who gave me both material and spiritual support in creating this volume. Without their friendship and a hefty push from Jesus Christ, Our Lord and Savior, nothing would have happened here. I thank you all heartily and pray this book meets your expectations.

—Tom Blumer

INTRODUCTION

In 1521, the first Spanish explorer to make contact with the Catawba came seeking Indian slaves. Lucas Vasquez de Ayllon taught the Catawba not to trust the white man when he kidnapped over 100 Indians and carried them away to slavery. This crime was not forgotten, for this crime was followed by others.

During the early 16th century, the area was known as Cofitachiqui (later known as the Catawba Nation and still later as South Carolina). In fact, the Indians, living in a highly organized Mississippian Culture, claimed some 55,000 square miles. The Catawba Nation covered most of modern South Carolina, central North Carolina, and an area around modern Danville, Virginia. This land base started to shrink when Charleston was settled in 1670. The colonization period was punctuated by land grabs, epidemics brought to the Carolinas by settlers, and a new, gun-dominated warfare, which was far more efficient that that practiced by the Indians before white contact. A shrinking population base made holding onto any land difficult.

The Treaty of Pine Tree Hill was signed in 1660 (at modern Camden); in this mysteriously lost document, the Catawba retained their claim to a mere two million acres mostly in central South and North Carolina. Three years later, in 1663, the Treaty of Augusta left the Catawba with a 144,000-acre claim. The Catawba managed to hold onto this land base until 1840, though most of the land was soon leased out to white settlers. The Treaty of Nations Ford (often called the Treaty of 1840) illegally deprived the Catawba of every acre of their former holdings, even lands not leased out. The treaty immediately became the source of friction between the Indians and the State of South Carolina. The State turned to yet another illegal solution and, in 1841, purchased the current 640-acre Old Reservation. The acres represented an island of desolation in the midst of some of South Carolina's richest farmland. Knowing this land did not meet treaty obligations and that it was virtually worthless, the Indians refused to move onto this reservation for over 10 years. Most important to Indian thought patterns, establishing a cemetery there would not happen for 20 years or longer. During this period, they continued to bury their dead on sacred land lost to them in the Treaty of 1840.

The Catawba population also suffered between contact and the Treaty of 1840. By 1840, the Catawba had dwindled from thousands to a mere 50 souls. For a long time, South Carolina looked for the Catawba to join the Carolina Parakeet, but such did not happen. The whole idea of reaching the settlement of their ancient land claim smoldered within the tribe as one tragedy after another was bravely faced. The first was the War Between the States (1861–1865),

a struggle for independence. This war alone carried away most of the able-bodied Catawba men. The war was followed by the deprivations of Reconstruction, which officially ended in South Carolina 12 years later in 1877. As soon as the Indians were able, they resurrected their land claim. It is a sad comment on the American judicial system that a settlement was not reached until over a century later in 1993. Throughout this long period of stress, the Catawba Indians kept body and soul together through the manufacture of pottery and day labor on surrounding farms. They thought not in terms of dollars but in terms of traded farm produce and pennies. Today we often think of their poverty as normal, but it was not. Remember, the Catawba once owned a vast land base that included parts of three states. The epidemics introduced by settlers in the 16th century finally came to a halt with the influenza epidemic of 1918. The first epidemic was recorded by Hernando de Soto's chroniclers in 1540, but some preceded that tragedy, which carried off entire towns.

The Indians have survived centuries of white contact and the wars and disease that came with the Europeans. In the process, they lost much of their culture, but much is left. The photographs collected record something of a small South Carolina Indian tribe with tremendous survival capabilities.

Today, the Catawba Indian Nation consists of over 2,000 people who are enrolled tribal members. Other Catawba who are not tribal members live in New Mexico, Oklahoma, and other Western states. These Indians should be on the tribal roll by virtue of descent and a clause entered into the Settlement Agreement of 1993. The reservation is about 20 miles south of Charlotte, North Carolina, off Route 77, and 8 miles east of Rock Hill, South Carolina. It consists of the 640-acre Old Reservation and the Carroll property purchased after the Settlement of 1993. Most of the Indians work in Charlotte or Rock Hill. A few Indians are employed by the tribe in the Long House, the cultural center, and other tribal offices. *Images of America: The Catawba Indian Nation of the Carolinas* begins with the Catawba firmly in possession of the Old Reservation.

One
FIRST PHOTOS

The art of photography came late to the Catawba Indians. The first photograph, actually a tintype, was made in 1861. This proves that the Indians did benefit from modern advancements. We are certain that Robert Head was not the only Catawba to visit a photographer's studio, but this is the earliest image to survive. From 1861 to 1900, most of the Indians lived in log cabins. These were heated by hearths connected to stick and mud chimneys. Naturally, such dwellings burned with great frequency. In such episodes, the Indians lost everything they owned, including photographs. This situation was accentuated by the late arrival of camera-wielding anthropologists on the reservation. The first to show an interest was Dr. Edward Palmer from the U.S. Bureau of Ethnology, who visited the reservation in 1884. If he brought a camera, no record of his efforts have survived. His field notes are lost, too. The next was M.R. Harrington, who did his celebrated series of the Brown family in 1907. The next year, A.I. Robertson did a series and it survives with the date 1911.

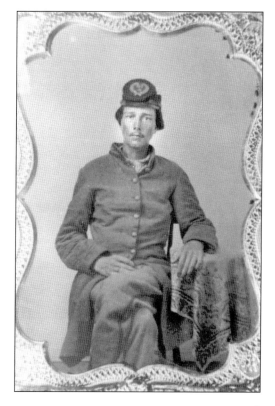

This oldest surviving Catawba image is of Confederate Army enlistee Robert Head. It was taken shortly after Robert Head joined the Confederate States of America Army at the beginning of the war. He left his wife, Martha, at home to tend to affairs. She was pregnant with their son Pinckney Head, who was born shortly after his father enlisted. In October of 1861, Robert came home on furlough to see his son for one time. He died in 1863 and never saw his son again. (Courtesy of Wayne Head, a direct descendant of Head.)

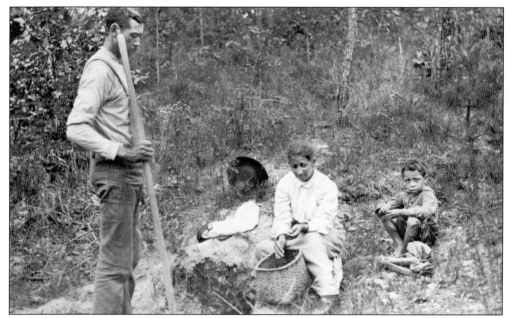

The first complete photographic series of the Catawba was done in 1907 by M.R. Harrington. He visited the Catawba Nation to record the Indians manufacturing their pottery. The family of John and Rachel George Brown agreed to do a series. These photographs were published in 1908 and have become classic. Here we have John and Rachel digging clay at their traditional clay holes in Lancaster County. The basket in which Rachel is placing picked clay is probably of Catawba make. The boy may be Jack Brown, who died in the influenza epidemic of 1918. (Courtesy of the National Museum of the American Indian.)

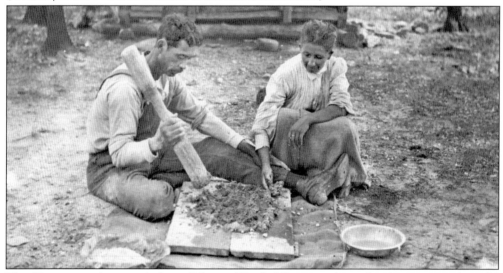

This Harrington photograph shows John and Rachel Brown picking the clay once it is brought home. John pounds the clay with a wooden mallet while his wife, Rachel, picks impurities such as roots and stones from the raw clay. The Indians discontinued this laborious process early in the 20th century when inexpensive window wire was introduced on the reservation. Martha Jane Harris discovered she could strain her clay through window wire and ended the old beating process seen in this photograph. (Courtesy of the National Museum of the American Indian.)

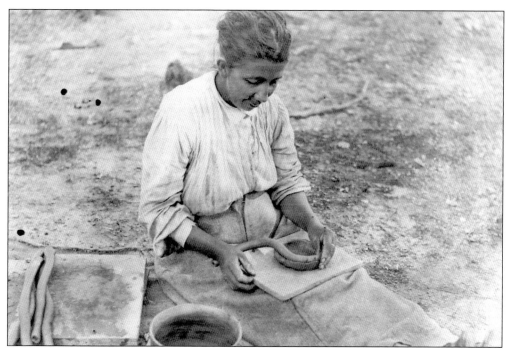

Harrington shows Rachel Brown starting the building process. She has a lapboard on her lap and uses this board throughout the process. A pot is begun with a flat base and then rolls are built up to the desired height. Additional rolls can be seen on the lapboard to the left. (Courtesy of the National Museum of the American Indian.)

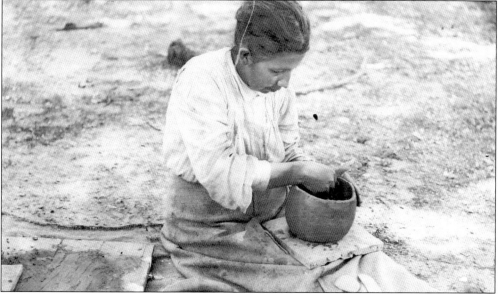

Harrington observed the entire building process. Once Rachel Brown places rolls up to the desired height, she smoothes the exterior of the vessel with a shell modeler. Her modeling tools rest on her knees within easy reach. The exterior smoothed, the potter then turns to the interior. As the potter obliterates the rolls on the inside, the vessel walls are pushed out so the pot can attain its final shape. (Courtesy of the National Museum of the American Indian.)

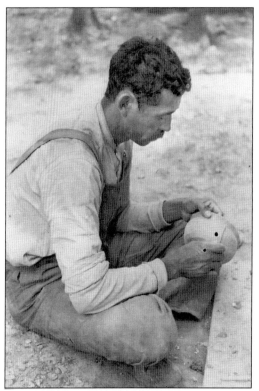

Harrington captured John Brown scraping a vessel built by Rachel. Once a vessel is dry enough to scrape, this task is carefully done, often by someone other than the potter. John Brown was celebrated for his ability to give a pot a smooth final shape, removing many bumps left in the building process. He uses a river cane knife. His son Early Brown followed in his father's footsteps and was known for his ability to scrape a pot to perfection. (Courtesy of the National Museum of the American Indian.)

The Brown family is burning their pottery in the open to show Harrington how the Indians used to burn pots. A small fire was built and the pots arranged in a circle around it so they could dry slowly. When the pots are totally dry, they turn a dark gray color. At this point, the potter piles wood on the vessels. The entire process takes the better part of a day. Normally the Browns would have burned in a fireplace inside the house. (Courtesy of the National Museum of the American Indian.)

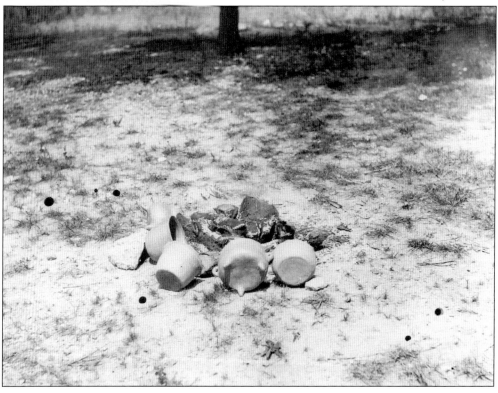

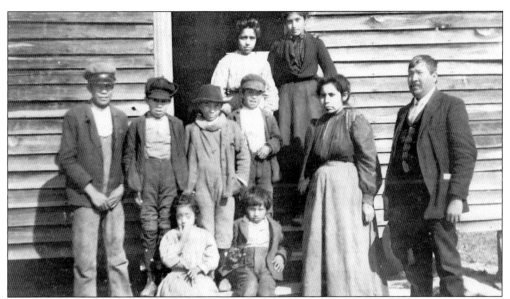

The second professional photographer to spend time on the Old Reservation was A.I. Robinson. In this historically important shot taken in 1911, we see Chief David A. Harris (Toad) on the far right with his wife, Della George, to his left. The two girls in the doorway are Sallie and Cora Brown. Cora died in the 1918 influenza epidemic, and Sallie went on to raise a family. All others are unidentified, with the possible exception of Jack Brown, who stands on the far left. He, too, was a victim of the 1918 epidemic. (Courtesy of the Smithsonian Institution, National Anthropological Archives.)

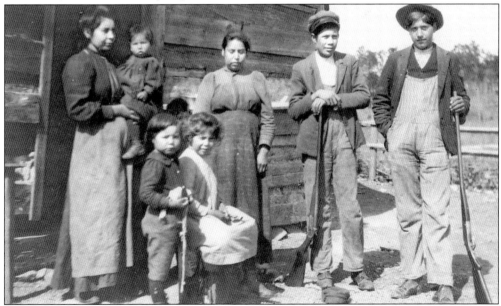

We are fortunate that Robinson caught two boys on their way to hunt in this series. All the Catawba men and boys hunted with a passion even though they were almost always restricted to birds, rabbits, and squirrels. The group poses in front of a log house. The adults, from left to right, are Della George, Dorie Harris, possibly Jack Sanders, and Harvey Blue. (Courtesy of the Smithsonian Institution, National Anthropological Archives.)

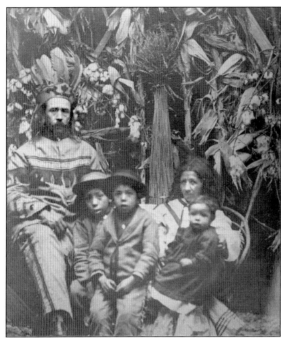

According to the records, the Catawba attended historical fairs as early as 1901 with the Charleston Exposition. The 1913 Corn Exposition held in Columbia was well attended by the Indians. Several photographs of the event remain in private collections on the reservation. The party attending included eight men, two women, and six children. This photograph is of the John and Rachel Brown family with three of their children. The family was decimated by the 1918 influenza epidemic, and it is doubtful that any of these children survived. (Courtesy of the late Georgia Harris.)

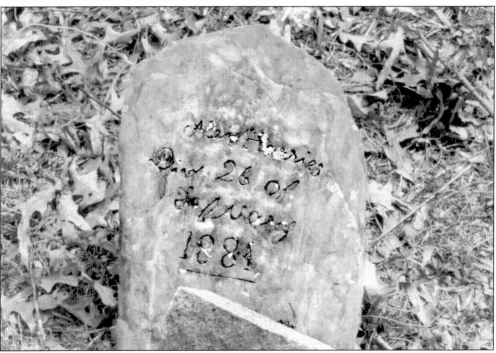

This photograph was taken recently at the Old Reservation Cemetery. This carved field stone memorializes Austin (Alan) Harris. According to his granddaughter Doris Wheelock Blue, "He was in a place he should not have been." On February 26, 1881, he was attacked, stabbed, and killed by three white men, all of whom were acquitted of murder. The Catawba abandoned their ancient cemetery in Lancaster County in the 1860s and buried their dead in this cemetery from that time until the 1950s.

Two

THE OLD RESERVATION

The State of South Carolina did not do the Catawba any favors when the so-called Old Reservation was purchased approximately three years after the Treaty of 1840. The Indians demanded the return of their land, which they had never leased out to white settlers, located in Kings Bottoms. This rich land was held by a John Doby, who refused to move, and South Carolina supported him. The State replaced this rich farm land now held by Doby with the nearly worthless reservation the Catawba still occupy. The Old Reservation consists of one square mile. From the 1850s to the 1940s, the Indians lived here almost exclusively. It contained a number of small houses, sometimes two families to a house; the Mormon church; the Catawba Indian School; and the services provided by one tiny convenience store. The Indians had trouble obtaining work other than occasional farm labor in nearby communities. Their entire world revolved around pottery making and cutting and hauling wood. They looked to their small community to provide work and entertainment. They enjoyed picnics; homes were stripped of furniture to allow for dances; and programs were held in the church, the only building capable of holding a crowd of any size.

This image, taken by an unknown photographer, has survived in various Catawba families for at least 80 years. Here a group of related Indians gather around matriarch Rhoda Harris, possibly on her porch. Included here are, from left to right, (front row) Margaret Harris and her son Furman Harris, Betsy Harris, daughter of Rhoda Harris; Nettie Harris Owl, granddaughter of Rhoda Harris; and Martha Jane Harris; (back row) Rhoda Harris. All of these women were master potters of the first rank. (Courtesy of Judy Canty Martin.)

The ruins of the old Nesbit Pavilion Dance Hall are located not far from the reservation across the Catawba River in Lancaster County. The Indians walked to the river and crossed in bateau boats. Once on the Lancaster side, they walked through the river bottoms and up the hill to the Dance Hall. At the turn of the 20th century, it was common for the Catawba to provide music. (Courtesy of R.P.S. Davis, Research Laboratories of Archaeology, University of North Carolina.)

The ruins of the old Dance Hall and some of the road leading from the building to the Catawba River are shown here. According to Indian lore, on this road, Peter Harris met the devil and learned from him to play "The Devil's Dream." Then they wrestled. Peter thought he could win in the match since the devil was in the form of a very small black man; however, Peter was soundly stomped. Peter was rescued by tribal members who heard his cries for help. It is possible the Catawba never visited the Dance Pavilion again. (Courtesy of RPS Davis, Research Laboratories of Archaeology, University of North Carolina.)

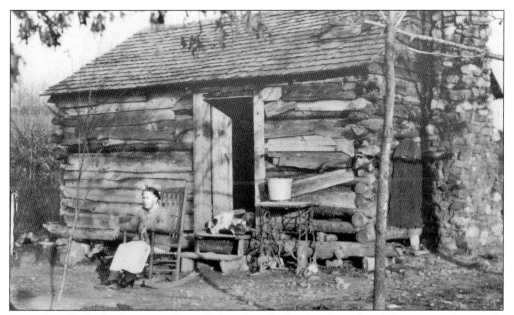

Betsy Crawford, also known as Betsy Bob, is here before her log cabin. This is a good example of the kind of housing the Catawba lived in at the end of the 19th century. Earlier they had stick and mud chimneys, but this later variety is made rock and mud. In this house, Betsy Crawford raised two orphan Catawba children: Clifford and William Watts. Betsy herself was a Civil War orphan, the daughter of CSA casualty Robert Crawford. (Courtesy of the Bureau of Indian Affairs.)

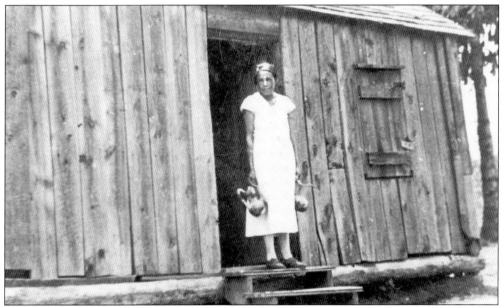

Edith Harris Brown's home was by this time a log structure covered with planks. Edith is standing in the door holding two Rebecca pitchers. This dwelling shows the old wooden shutters the Catawba employed in the years before they could afford window glass. As has been the case with most reservation dwellings, this house was replaced by a more modern home. (Courtesy of the Bureau of Indian Affairs.)

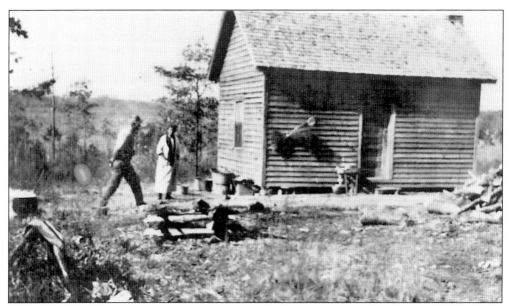

This one-room house was constructed by Herbert Blue for his first wife, Lavinia Harris. It exhibits the improvements of window glass, but its roof shingles were handmade. The house was constructed with money earned by Herbert working in the cotton mills of Rock Hill. After Lavinia's death, Herbert sold the house to his aunt, Sallie Gordon. (Courtesy of Roger Trimnal, a descendant of Herbert Blue.)

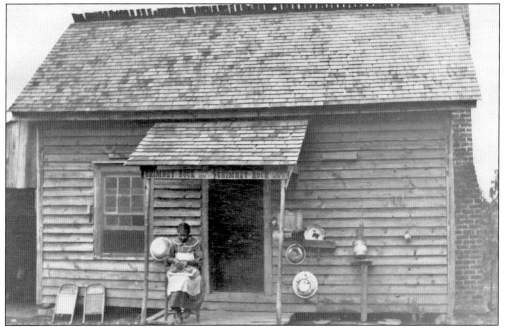

After Sallie Brown Gordon obtained this house, she made several improvements. Note the modern brick chimney and the addition of an extra glass window to the front of the house. The roof shingles still appear to be handmade. The Chimney Rock sign over the door was obtained during a pottery peddling trip to the mountains of North Carolina. Sallie is making pottery on a lap board. (Courtesy of an anonymous tribal member.)

Richard Harris's home was constructed on the site of Edith Brown's original log cabin. It was occupied by Richard Harris and purchased by Big Gary and Frances Wade after Richard's death. It was later occupied by Sallie Harris Wade until her death. The old house was demolished by Little Gary Wade, who lives on the site today in a modern home.

This house was built for Sallie Brown by her husband, Fletcher Beck, and his uncle Major Beck. Sallie and Fletcher raised a family here. After Sallie's death, Helen Beck remodeled the house. Today it is occupied by Collette Williams Bell, Sallie's great-granddaughter.

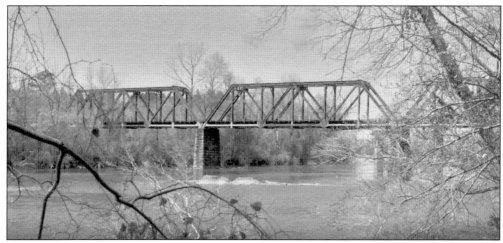

This railroad bridge connects Van Wyck and Catawba Junction. For many years, the Indians walked this bridge if they lacked money to ride the Catawba Indian Ferry or if a bateau was not available. Georgia Harris walked this bridge c. 1917 with her grandmother Martha Jane Harris on a peddling trip between the reservation, Van Wyck, and Catawba Junction. (Courtesy of Catawba River photographer Bill Price.)

The Catawba Indian Ferry is shown looking from York to Lancaster County. The Indians operated this ferry from the early 19th century to 1959. The ferry was discontinued when a bridge was built on Route 5. (Courtesy of Howard George.)

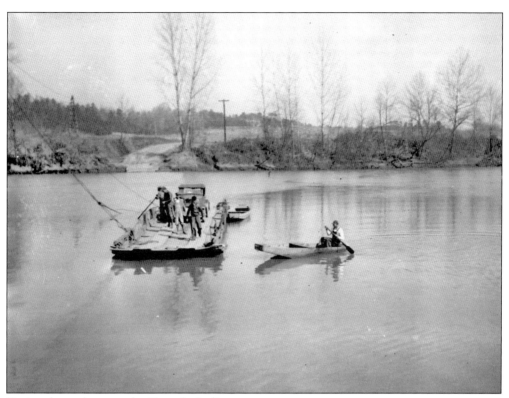

During the early years, the Catawba Indian Ferry was poled across the river by hand. The automobile being carried across the Catawba River may give us an idea of the year this photo was taken. The man on the right is paddling a bateau. (Courtesy of Howard George.)

Here the Catawba Indian Ferry is being poled across the river. Howard George is in front followed by a man in shorts who seems to be helping as his car was in the process of being transported across the river. The photo was taken on May 11, 1941. (Courtesy of Howard George.)

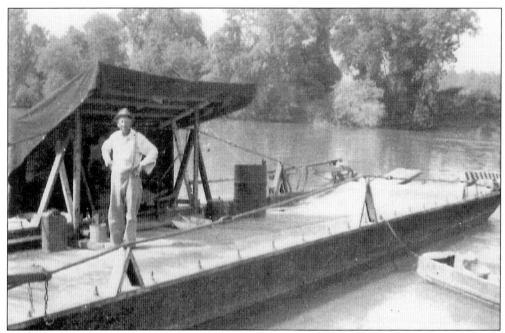

Early Brown stands on the Catawba Indian Ferry he ran for many years. By this time, the ferry was motor operated rather than hand operated. The motor is located in the shed behind Early. For many years, Howard George assisted Early, his grandfather. When Early Brown retired, Howard took over the job until the ferry closed in 1959. (Courtesy of Howard George.)

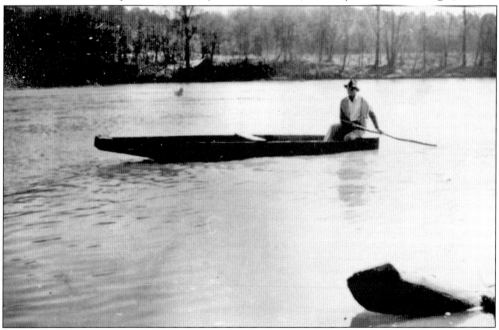

Here a Catawba Indian is paddling a bateau on the river. These homemade boats replaced the old dugout canoes. They were made from plank lumber and commonly used to cross the river. If some of the women needed to go to Van Wyck, they would often find a man to take them across in a bateau. (Courtesy of the Bureau of Indian Affairs.)

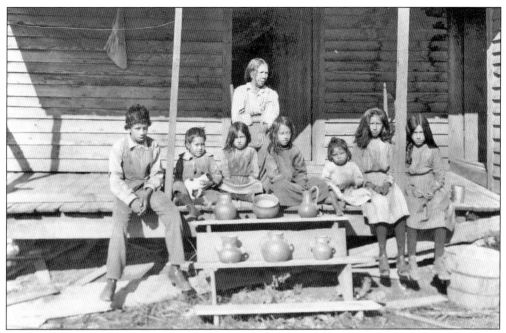

This photograph was taken c. 1910. Sarah Ayers Harris, widow of Confederate States Army veteran James Harris and mother of Chief James Harris and Chief David Adam Harris, rests on her porch surrounded by her grandchildren. Her pottery is displayed on a makeshift wooden bench. (Courtesy of the Library of Congress.)

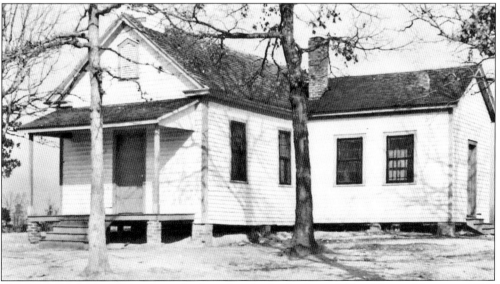

The Catawba Indian School was built under the leadership of Chief James Harris in 1896. Money was put aside for hardware, and the wood was cut on the reservation. The first teacher was a Presbyterian by the name of Mrs. Dunlap. The earliest roster of students is from 1899 and includes the following names: Nora Brown, Lucy George, Maroni George, Nelson Blue, Early Brown, Wade Ayers, Sallie Brown, Sallie Harris, Lillie Blue, Edith Harris, Lavinia Harris, Leola Watts, Artemis Harris, and Arzada Brown. This school served the tribe until Federal Recognition (1941). (Courtesy of the Bureau of Indian Affairs.)

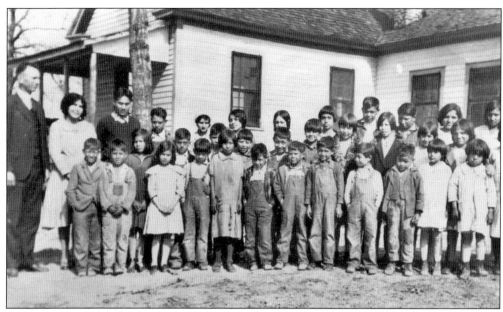

A group of Catawba children stand before the Catawba Indian School in 1931. The teacher at the far left is Willard Hayes. The older girl standing next to Hayes is Elsie Blue (later George), who served as a teacher's helper for several years. (Courtesy of the Bureau of Indian Affairs.)

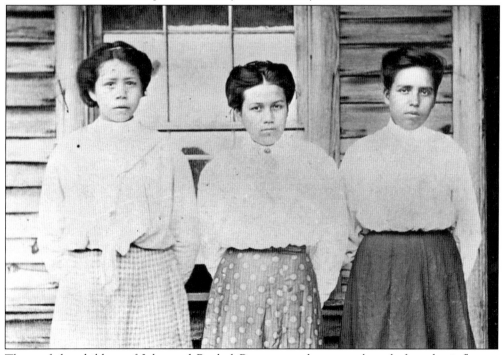

Three of the children of John and Rachel Brown pose here, not long before the influenza epidemic of 1918. From left to right they are Arzada, Maggie, and Cora. Both Maggie and Cora died of the influenza. Arzada married John Idle Sanders, raised a family, and became a potter of note. She also cooked in the Catawba Indian School built during the Federal Wardship period. (Courtesy of an anonymous tribal member.)

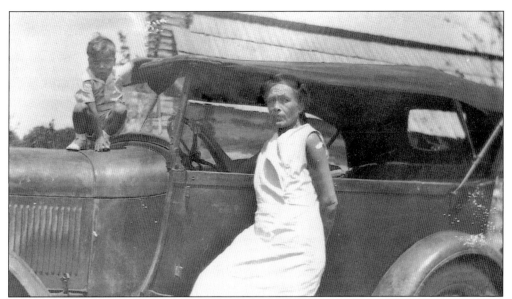

In the 1930s, a group of Indians led by Early Brown traveled to Schoenbrun, Ohio, to make pottery. Here Emma Harris Canty Brown poses next to the Model A that the Indians drove to Ohio. The car went loaded with passengers, belongings, clothing, pottery tools, and clay. This was possibly the first car on the reservation. It may have been purchased by John Brown, Early's father, some years before. The child squatting on the hood is Howard George. (Courtesy of Howard George.)

Here we have a group of Catawba Indians who worked at Schoenbrun, Ohio, under the direction of Emma and Early Brown. They are, from left to right (front row) Howard George, Charlie George, and Faye George; (back row) Elizabeth Plyler, Emma Brown, Early Brown, Evelyn George holding Joann George, and Marvin George. They lived in reconstructed frontier cabins and demonstrated and sold pottery every day. (Courtesy of the Bureau of Indian Affairs.)

Mormon missionaries arrived in York County c. 1882. The Catawba were immediately attracted to the Mormon faith. For the most part, they abandoned their Baptist, Methodist, and Presbyterian roots. At first the Indians met in arbor churches. By 1883, 37 had been baptized by the Mormon missionaries. This church was built probably in the late 1880s and expanded in the early 20th century. (Courtesy of the Smithsonian Institution, National Anthropological Archives.)

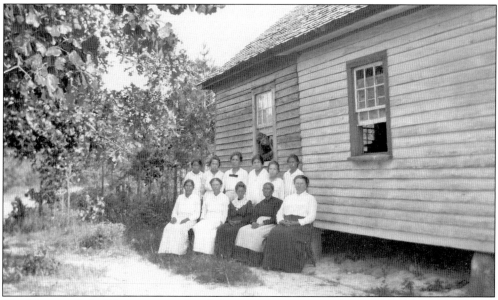

The Mormon Relief Society immediately became important to the newly converted Catawba Indians. The society provided the Indians with assistance in times of need. Shown here are, from left to right, (front row) Louisa Blue, unidentified, Dovie Harris, Margaret Brown, and Lillie Sanders; (back row) Emma Brown?, Lula Beck, and Bertha Harris. The building's addition can be seen to the rear. (Courtesy of the Smithsonian Institution, National Anthropological Archives.)

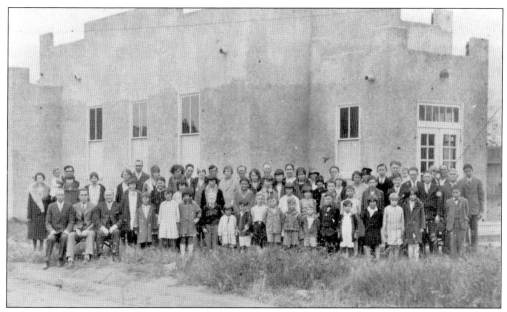

The second Mormon church built on the reservation was constructed in 1928 to replace the original frame building. It was constructed by Elder W.L. Bell, who visited from Idaho. This church filled the needs of the growing Catawba Nation; however, its western design with a flat roof and stucco could not stand up well under South Carolina's damp climate. Today it is commonly referred to as the stucco church. (Courtesy of an anonymous tribal member.)

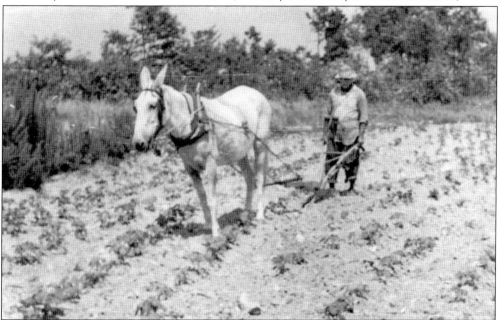

The State of South Carolina did not do the Indians any favors when the Old Reservation was purchased following the Treaty of 1840. Although the reservation possessed some rich river bottom land, these areas were often flooded by the Catawba River. The Indians could only depend on small family plots on upper ground, which was of little value for farming. (Courtesy of the Bureau of Indian Affairs.)

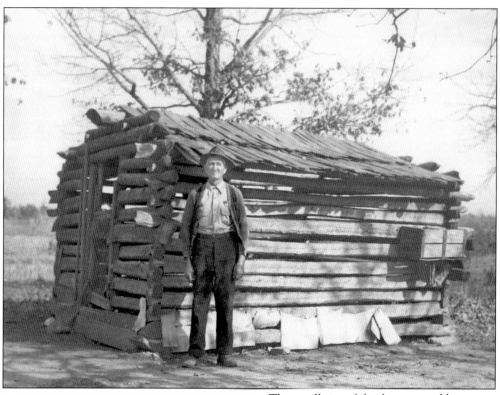

The small size of this barn owned by Samuel T. Blue, who stands proudly in front, tells us something of the farming practiced by the Catawba on the Old Reservation. Samuel Blue was a primary farmer on the reservation, but his resources were poor. (Courtesy of the Bureau of Indian Affairs.)

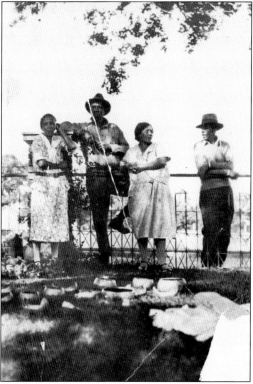

After Winthrop College (now Winthrop University) opened its doors to students, President David Bancroft Johnson allowed the Catawba Indian potters to set up shop and sell their wares at the college gates. Most sales were made to the students, who often traded school uniforms for pottery that they sent home as gifts. Shown from left to right are Edith Brown, Irvin Gordon, Eliza Gordon, and Roy Brown. (Courtesy of the late Edna Brown.)

Dovie George Harris was for several generations a popular storyteller on the reservation. For years she both fascinated and terrorized children with her snake stories. When she was on her death bed, she often chanted, "All ye snakes and lizards come unto me." She often claimed to whip her children with a black snake. Her stories are still told with gusto even by young Indians who never knew her. (Courtesy of Melvin Harris.)

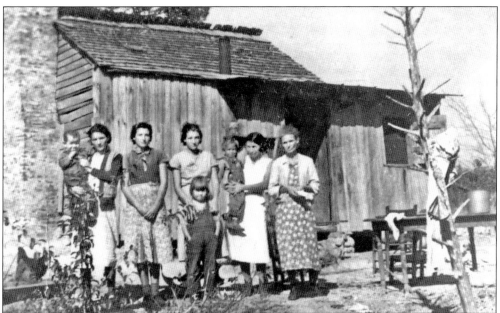

This group of Indians stands before the home owned by Luther and Pearly Ayers Harris. Some of this extended family group can be identified, from left to right: three of Maggie Harris's daughters, Pearly Harris holding one of her children standing next to Maggie Harris. This small house was often home to more than one family in spite of its small size. Upon their arrival on the reservation, the Robbins family joined the Harris family under this roof. (Courtesy of the Bureau of Indian Affairs.)

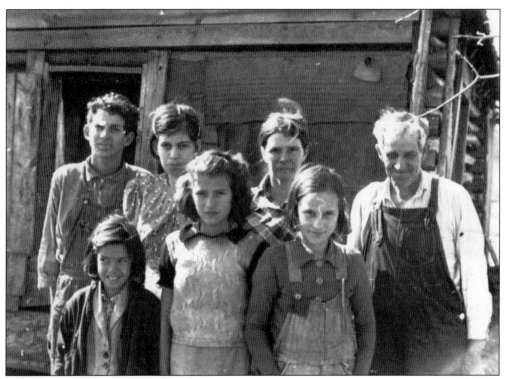

The Robbins family moved from Chesnee, South Carolina, to the reservation in the early 1930s. They lived at first with Pearly and Luther Harris and later built a one-room log home. It was built by Luther Harris and Frank Robbins in 1935. Shown here are left to right are (front row) Christine Harris, Lillian Harris, and Faye Robbins; (back row) Earl Robbins, Ester Robbins, Effie Harris Robbins, and Frank Robbins. (Courtesy of Earl Robbins.)

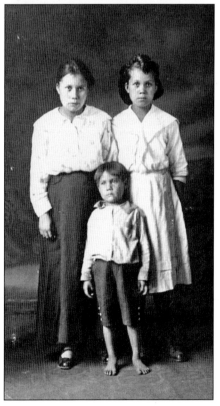

Here Georgia Harris (left) and Eliza Harris Gordon (right) pose with their brother Furman Harris. Georgia went on to marry Douglas Harris and become a major 20th-century potter. Furman married Bertha George, another prominent potter. Eliza married Irvin Gordon and was a well-known Catawba potter who sold from New York to South Carolina. (Courtesy of the American Philosophical Society.)

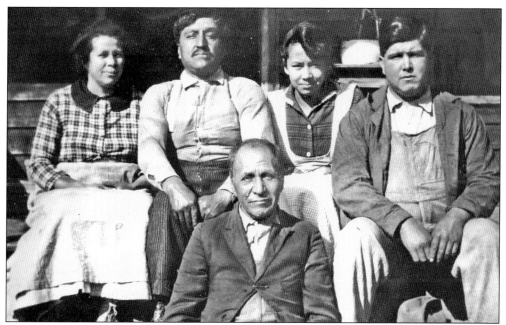

Rosie Harris, left, met Archie Wheelock (Oneida), center, while at Carlisle Indian Industrial at Carlisle, Pennsylvania. Their daughter Doris Wheelock married Andrew Blue, to right of Archie, around the time this photograph was taken. William Harris, better known as Billy Bowlegs, front center, lived with the Wheelock family. Billy Bowlegs was celebrated for his horse effigy pots. (Photo by F.G. Speck in 1922; courtesy of the American Museum of the American Indian.)

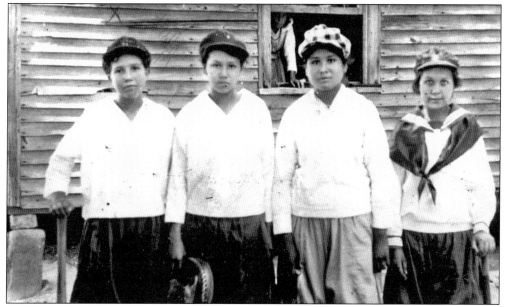

The Catawba men's baseball team was celebrated and won games wherever they played. Here we have four members of the little-known Catawba girls' baseball team represented from left to right: Jeannette George, Doris Wheelock Blue, Lula Blue Beck, and Georgia Harris. (Courtesy of the late Georgia Harris.)

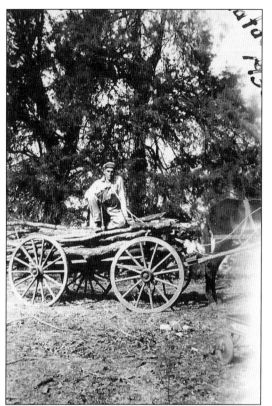

Douglas Harris is doing something here that was a common livelihood for the Catawba men until work in the Rock Hill cotton mills became the norm—cutting cord wood for 50¢ a cord. Here Douglas is on his way to sell a small load of wood, which appears to be wood he picked up off the forest floor. Douglas and his wife, Georgia, made a living from his day labor and her pottery. (Courtesy of David Garce.)

Although Mildred Blue was among the first to obtain an education in the white schools off the reservation and the first Indian to graduate from Rock Hill High School, work was denied to her. So that Mildred might make a living of some sort, her family combined resources and built a small store in her yard where Mildred sold soda, candy, and all kinds of snack food. Mildred closed her store when she obtained work in Rock Hill. (Courtesy of the Bureau of Indian Affairs.)

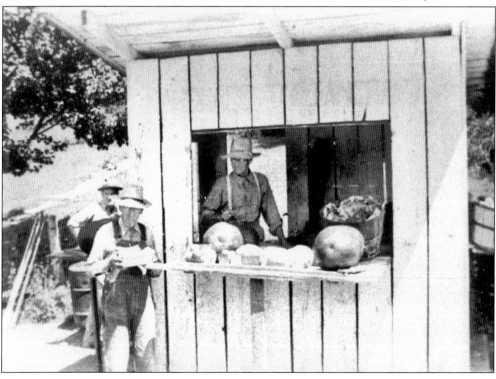

Edith Harris married Early Brown and they started a family. By this time, Early was running the ferry and had a regular salary, something few of the Catawba could boast of having. Here two of the couple's children pose for a formal portrait c. 1914. Evelyn Brown (later George) is the baby, and Edward Brown is her big brother. (Courtesy of Marcus Sanders.)

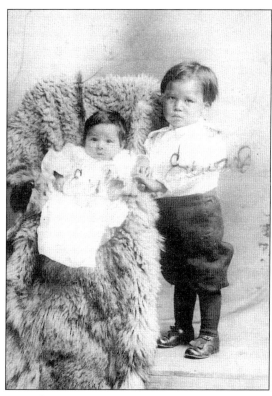

This large extended family group stands before Sallie Brown Gordon's home. From left to right they are Ruby Ayers, Floyd Harris, Sallie Gordon, Georgia Harris, Dewey Harris, Eliza Gordon, and Gladys Gordon. All of the women in this photograph were potters of note. (Courtesy of the late Georgia Harris.)

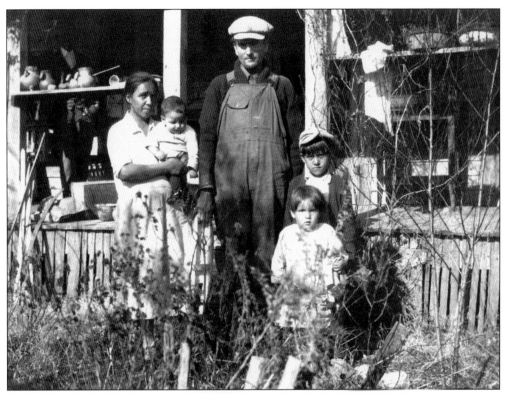

Here Sallie Brown stands with her husband, Fletcher Beck, probably in front of Lillie Beck's home. This dwelling was most recently occupied by Edith Brown and still stands waiting for restoration. It is possibly one of the oldest houses on the reservation. From left to right are Sallie, holding her son Samuel; Fletcher; and Irene and Eugene Beck. Several pieces of pottery made by Lillie Beck Sanders can be seen on the far left. (Courtesy of an anonymous tribal member.)

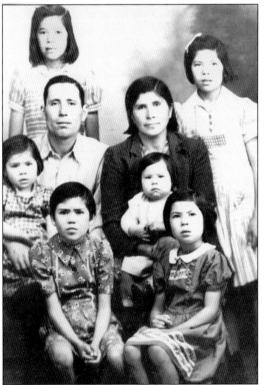

One of the largest families in the Catawba community was raised by Chief Albert Sanders and his wife, Eva Blue. Shown here from left to right are (front row) Leone and Laura Sanders; (middle row) Brenda and Juanita Sanders; (back row) Ada and Lois Sanders, Albert, and Eva. Albert was chief of the Catawba during termination and claimed that the election of Gilbert Blue was illegal because of a lack of a legal quorum. (Courtesy of the late Georgia Harris.)

Three

PERSONALITIES

After the Indian removal to west of the Mississippi, the Catawba Nation was isolated from other Indian communities other than occasional visits to the Cherokee in North Carolina. Contacts with blacks were shunned, and contacts with whites were limited. Work of any steady nature off the reservation was nearly impossible to obtain. The Indians relied on their own resources for entertainment. The women made pottery, and the men assisted the women and sometimes made pottery on their own. The men always helped dig the clay, and they peddled pottery throughout the Carolinas. After the Catawba obtained automobiles, they were able to peddle pottery in the mountains of North Carolina and other far-off places. For the most part, the Catawba were left to their own resources. They looked inward and continue in many ways to look inward. We have already talked of some personalities who were important to the community, but there are many more who stood above the others for work skills, entertainment, and just plain human interest.

Betsy (Bob) Crawford was a Civil War orphan. Her father joined the Confederate States Army with the rest of the Indians. He was last paid on December 31, 1862, and was later assumed dead. Betsy married Robert Lee Harris and ever after was referred to as "Betsy Bob" even though the marriage did not last long. She surprised both Robert and the community when she ran off with John Sanders. Late in life, she married a white man by the name of Estridge and ran a country store. She had no children of her own but raised two orphans, Clifford and William Watts. Today Betsy Bob Road is named for her. (Courtesy of an anonymous tribal member.)

The Catawba Indian Confederate Monument in Fort Mill was dedicated on July 31, 1900. A party of 50 Catawbas attended the ceremony. Although the monument is not fully accurate as to who served the cause, it lists a number of Indians, most of whom died in battle or came home crippled: Jefferson Ayers, John Harris, Jim Harris, Peter Harris, John Scott, William Canty, Robert Mursh, John Brown, Alexander Tims, Billy George, Bob Crawford, John Sanders, Bill Sanders, Gilbert George, Nelson George, Epp Harris, and Bob Head.

James Harvey Watts first appears in the records as running the Cureton Ferry on the Catawba River with Tom Steven. James Watts and his wife, Mary, raised Leola (Watts), who was abandoned by her white mother. Late in life, James Watts had two sons: William and Clifford, who were orphaned upon James Watts's death in March 1923. (Courtesy of Clifford Watts.)

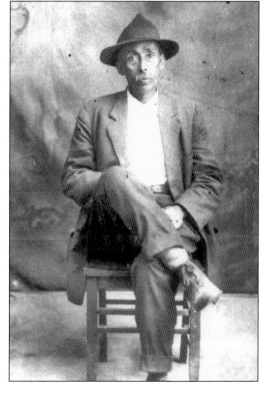

Emma was born a member of the Harris family. She was married early in life to Henry Canty and had a family by him. She basically raised her children alone because of Henry's dependence on drugs and alcohol. In time, she left Henry and lived with Early Brown, her childhood sweetheart, and she is best known as Emma Brown. Throughout her life, she produced a high quality pottery ware, which she peddled in towns around the reservation. She and Early worked at Schoenbrun, Ohio, in the mid- to late 1930s.

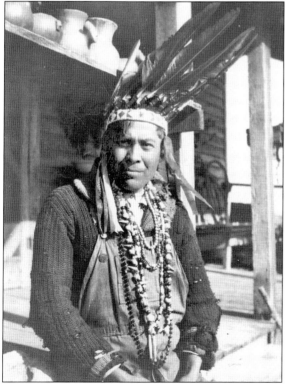

Joseph Sanders was the son of John Sanders and Martha Harris. He attended Carlisle Indian Industrial in Carlisle, Pennsylvania. Joseph also served his country during World War I. After the war, he married Lillie Beck, a member of the Cherokee Nation. He was a frequent informant for anthropologists visiting the reservation. He died in February 1930. Here he is dressed in his regalia. His wife's pottery, made in the Catawba tradition, may be seen on the shelf above him. (Courtesy of the American Philosophical Society.)

Maroni George was the son of Taylor George and Emily Cobb. He went to Carlisle Indian Industrial in Pennsylvania in 1899. He was so unhappy there that he ran away at least once. Here he is pictured in his Carlisle uniform. (Courtesy Bertha George Harris.)

William Harris (Billy Bowlegs) was a personality of interest on the reservation for his entire life. In 1881, he was charged with assault and battery on Taylor George. In 1887, he went to Columbia to investigate the ancient Catawba land claim. He spoke at the unveiling of the Catawba Confederate Monument in Fort Mill. He appeared before the South Carolina Legislature to appeal for assistance for the tribe. Even after the majority of the Catawba converted to the Mormon faith, Billy Bowlegs remained a Presbyterian. He was also a language informant for Truman Michelson in 1913. (Courtesy of the National Museum of the American Indian.)

Margaret Wiley Brown first entered Catawba history on a pottery peddling trip to Gastonia, North Carolina, in 1905. She was a native Catawba speaker and assisted a number of linguists, including Truman Michelson (1913), John Swanton (1918), and Frank G. Speck (1922). She was a major informant for Speck's *Catawba Texts*. She died in 1922. (Courtesy of the National Museum of the American Indian.)

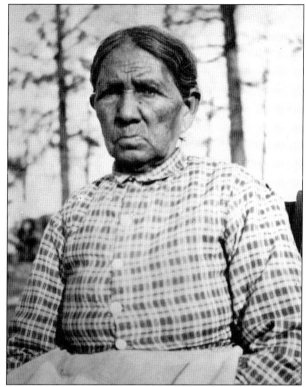

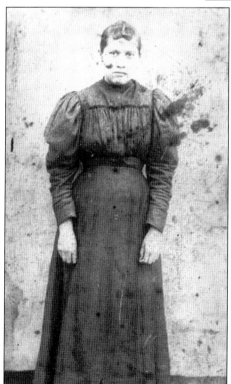

Margaret Harris was the only child of Epp Harris and Martha Jane Harris. She accompanied her parents on a long visit to the Pamunkey Indian Tribe in Virginia in the 1890s. At the end of their visit, the family lacked money to take a train back to South Carolina, and they walked home, following the railroad tracks. Margaret was an informant for Theodore Stern, who was a student of the Catawba and Pamunkey pottery traditions. She is best known as the mother of Georgia Harris. (Courtesy of the late Georgia Harris.)

This photo was taken of David Adam Harris (Toad) late in life. He was chief of the Catawba during the early 20th century and did as much as he could to further the Catawba land claim against South Carolina from 1905 to 1915. His political career was ruined in 1917 when he shot and killed his wife, Della George. Though he was acquitted of murder, he found forgiveness difficult to obtain. He died in September 1930. (Courtesy of the American Philosophical Society.)

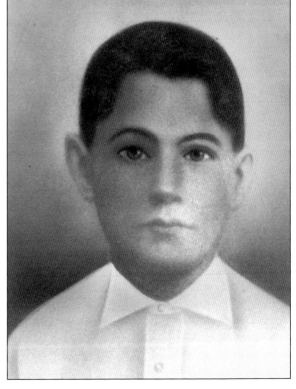

Harvey Blue was the son of Samuel T. Blue and Louisa Canty. He was shot during a squirrel hunting party that contained several adult men and two youths. One of the men gave Harvey a knife to coax him up a tree to flush some squirrels out of their nest. The men promised not to shoot until Harvey was free and clear of the nest. Instead, they shot immediately, filling Harvey with shot from several different guns. The incident was judged an accident. (Courtesy of Elsie Blue George, Harvey's sister.)

Effie Harris Robbins was the daughter of Ed Harris and Ester Price. She was born on the Catawba reservation but grew up and raised her family in Chesnee, South Carolina, until the 1930s. At that time, she returned home. At first the family lived with Pearly and Luther Harris and later built a one-room log cabin. Her siblings were Maybelle Robbins and Henry Harris. The best known of her children is the potter Earl Robbins. (Courtesy of Earl and Viola Robbins.)

Rosie Wheelock was the daughter of Austen Harris and Nancy Whitesides. Rosie's father was killed in a brawl before her birth, and she was raised by her grandmother Rhoda Harris. In 1895, she was sent to Carlisle Indian Industrial to get an education. While there, she met Archie Wheelock, whom she later married. In 1908, A.I. Robinson helped Rosie with a pottery studio in Washington, D.C. In 1931, she testified before the U.S. Senate regarding conditions on the reservation. Here she is pictured with her daughter Doris Wheelock. (Courtesy of the late Doris Blue.)

Frank Canty was married to Dorothy Price for a short time. The marriage produced no children. He, like his brother Henry, was hopelessly addicted to any harmful substance he could obtain. After a baseball game where he had consumed rubbing alcohol, he stopped at a country store and purchased crackers and cheese. The alcohol and the cheese caused a violent reaction in his stomach and killed him. (Courtesy of the National Museum of the American Indian.)

Frank's brother, Henry Canty, was hopelessly addicted to any intoxicating substance. His death was a horrible one. On his way home and in a drunken condition, he slept in a straw field on the reservation. When he awoke the next morning, he lit his pipe and caught the straw on fire. His cries for help were soon heard, and many Indians saw him burning in the field. By the time the Indians came to the rescue, his clothing had been burned off. He died that night. His son Alonzo Canty initiated an investigation, but no foul play was found. (Courtesy of the late Jennie Brindle.)

E. Fred Sanders is the son of John Idle Sanders and Arzada Brown. He served his country in World War II on the European front. After the war, Fred became a barber. He was assistant chief from 1974 to 1993, when he resigned over the tribe's loss of jurisdiction in the Settlement Bill. He soon became one of Chief Gilbert Blue's most severe critics. He was elected councilman by the Traditionalist Faction under Chief Bill Harris in September 2002. (Courtesy of E. Fred Sanders.)

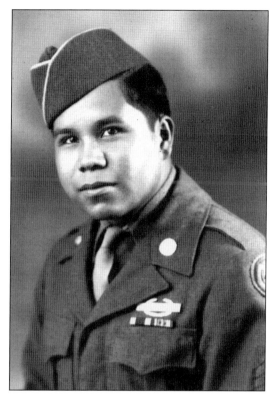

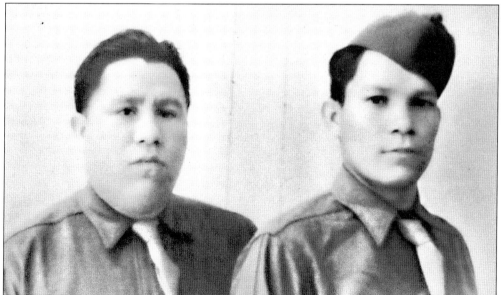

Here we have brothers Garfield C. (left) and Wilford Harris (right) in their World War II uniforms. They were the sons of Theodore and Artemis Harris. Both served on the European front. Garfield spent much of his time in the liberation of Italy. He was secretary/treasurer during Termination (1959). Wilford was a member of the Money Faction during the Settlement Period and served on the Executive Committee by special arrangement until his death. (Courtesy of the late Garfield C. Harris.)

Sallie Harris Wade was the daughter of Ben P. and Dovie George Harris. Sallie was one of the first children to attend the Catawba Indian School. In 1919, she married Altho Wnith. In the 1930s, she married Will Wade. She made pottery for much of her life and peddled it in communities near the reservation and at Winthrop College. In 1976, she prompted this author to begin his serious study of the Catawba Indians. (Courtesy of an anonymous tribal member.)

Sallie Brown Gordon was the daughter of Confederate veteran John Brown and Margaret George. She was a native Catawba speaker and never really possessed a good grasp of English. She married Lewis Gordon, who left her a widow in 1926. She assisted Frank G. Speck in his classical language study *Catawba Texts*. She was a frequent informant for historians, newspaper reporters, and other students of the Catawba. She constantly worked in clay and kept a pipe in her pocket so she could work on it when she had a moment. Sallie died of cancer in 1952. (Courtesy of the American Philosophical Society.)

Earl Robbins and Viola Harris were married on March 27, 1941. They were both 20 years of age, and this photograph was taken on their wedding day. Earl soon built his wife a two-room house, and they began to raise a family. This is the one of the few wedding day photographs from the period. (Courtesy of Earl and Viola Robbins.)

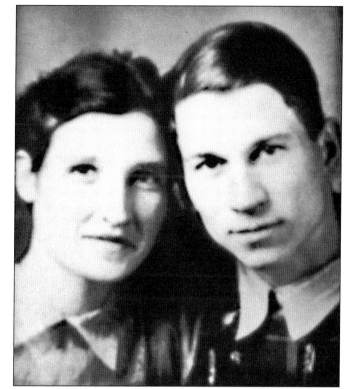

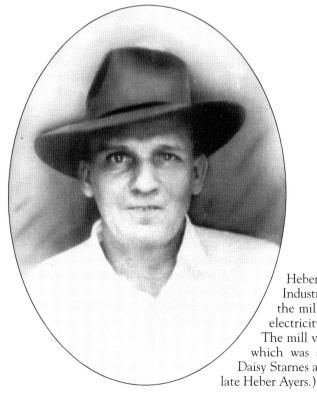

Heber Ayers worked his entire life for the Industrial Mill in Rock Hill. He lived in the mill village where his rent, water, and electricity were taken from his paycheck. The mill village also contained a commissary, which was available to workers. He married Daisy Starnes and raised a family. (Courtesy of the late Heber Ayers.)

After Maroni George finished his studies at Carlisle Indian Industrial, he returned home to work. He taught night classes for adults in the Catawba Indian School and was on the Land Committee in 1941. For many years, he farmed on the reservation and eventually moved to York, South Carolina, where many of his family members remain. He died in 1979. (Courtesy of the Bureau of Indian Affairs.)

Georgia Harris was the daughter of Chief James Harris and Margaret Harris. She married Douglas Harris in 1924 and had two sons: Floyd and Dewey. Here she is pictured holding Dewey. The family lived at the old home place, now on Hagler Drive. After the tribe gained Federal recognition, the Harris family moved to the New Reservation on the outskirts of Rock Hill. Today Dewey has a family of his own and lives in Ohio. (Courtesy of the American Philosophical Society.)

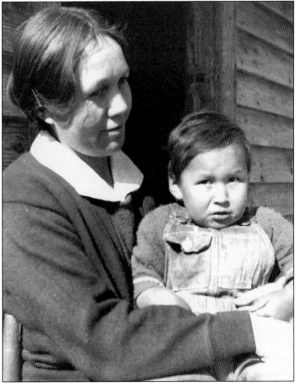

Rachel George Brown was the daughter of Taylor George and Emily Cobb. She married John Brown, who operated the Catawba Indian Ferry. The Browns did well financially between the ferry income and Rachel's pottery sales. In 1907, the family was approached by M.R. Harrington, and they agreed to do a photo series on the manufacture of Catawba pottery. This work was published in 1908 in the *American Anthropologist* and has since become a classic Catawba study. Today Rachel Brown is fondly called Aunt Wysie or Grandma Wysie by those who knew her.

Martin Harris was the son of Chief Raymond Harris and Nola Harris, better known by the name Campbell. This master potter learned to make pottery from his aunt Isabelle Harris. The two of them also worked with Alberta Ferrell. In his later years, Martin worked with his mother, Nola Campbell. He died in 2003.

Eliza Jane Harris Gordon was the daughter of Chief James Harris and Margaret Harris. She married Irvin Gordon and made pottery for most of her life. In 1944, she assisted Frank G. Speck in his "Catawba Herbs and Curative Practices." During this period, she also worked at pottery making in Tannersville, Pennsylvania. She had one daughter, Gladys Gordon Thomas. (Courtesy of the American Philosophical Society.)

Faye George Greiner is a daughter of Marvin George and Evelyn Brown. She spent her early summers at Schoenbrun, Ohio, where she watched her parents make pottery with Emma Brown. During her years at the Cherokee Boarding School, she learned to make split baskets and is the only basket maker among the Catawba. She often holds basket-making classes for the Cultural Center. She makes pottery and learned this art form from her mother, Evelyn George; Nola Campbell; and Earl Robbins.

Billie Ann Canty McKellar is the daughter of Billie Canty and Catherine Sanders. She attended the pottery class of 1976 and was one of its star pupils. Today she is ranked as a master potter but spends most of her time as archivist for the Catawba Nation Archives, located in the Catawba Cultural Center. She is the great-granddaughter of Rachel Brown; the granddaughter of Arzada Sanders; and the daughter of Catherine Canty, all master potters of the first order. (Courtesy of Steve McKellar.)

Howard George is the son of Marvin George and Evelyn Brown. As a teenager he went to work on the Catawba Indian Ferry for his grandfather Early Brown. Howard learned to pole the ferry across the river by hand and saw a day when the ferry was run by a motor rather than brute strength. He was running the ferry when it closed in 1959 upon the opening of the Van Wyck Bridge. For the balance of his career, he worked for the South Carolina Highway Department.

Isabelle George was the daughter of Chief David Adam Harris and Della George and was a housewife. She married Robert Harris, the son of Dovie Harris. After Robert's death, she married Ephriam George. She made pottery for the North Carolina Mountain trade.

Susan George (sometimes known as Cousin) is a daughter of Marvin George and Evelyn Brown. After the Settlement of 1993, she went to work for the tribe. Today she works as the administrative assistant for program operations. She has made pottery for a number of years and is an accomplished potter.

Four

THE WESTERN CATAWBA

Mormon missionaries started working in York County c. 1881 and almost immediately visited the Catawba Indian Nation. By 1887, a large number of the Catawba had been baptized into the Mormon Church. The Catawba were caught up in the Mormon migration to the West. According to Wayne Head: The Indians "left Catawba by train and traveled to Westport, Missouri, near St. Louis. They crossed the Mississippi, then took wagons to Parowan, Utah, later going to Sanford, Colorado," where they settled. This move took place in 1887. They left a poverty-stricken reservation and a community with little hope of obtaining work in the local area for a brighter future in the West. The photos included here show that the move was a wise one financially. Culturally, however, they were cut off from their roots. During the last 120 years, members of the Western Catawba have made trips home to Catawba. The Catawba of South Carolina have also gone West to visit relatives and maintain contact. A large group of Catawba, many of the Harris family, also reside in Oklahoma and Texas. They, too, have kept contact with cousins at home in South Carolina.

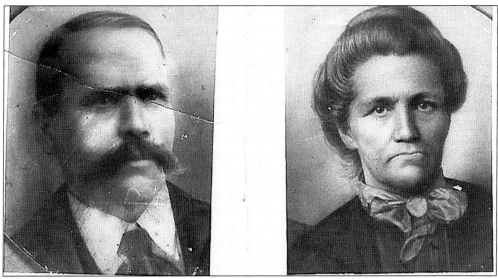

James Patterson, a Confederate States Army veteran, was the undisputed leader of those Catawba who moved west in 1887. He was one of the earliest converts to the Mormon faith. Upon arrival, James and his wife, Elizabeth Missouri White, pictured here, lived in caves on the Rio Grande River. He cut wood in the Fox Creek area. Ironically, he was doing much of what his cousins at home were doing—cutting cord wood. He also farmed and ranched in addition to hauling wood. (Courtesy of David Garce.)

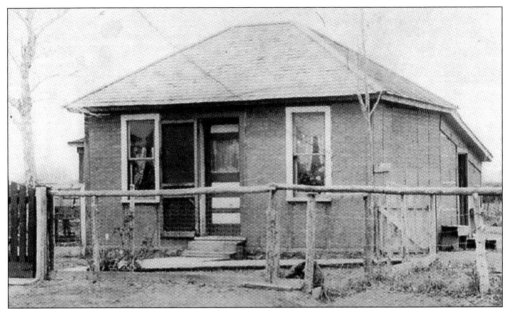

This is the first real home the Pattersons enjoyed. It was located in Sanford, Colorado, where the family could keep contact with fellow Catawbas. It had two bedrooms, a huge improvement for a Catawba Indian family, but no running water or electricity. It was torn down in the 1930s. (Courtesy of David Garce.)

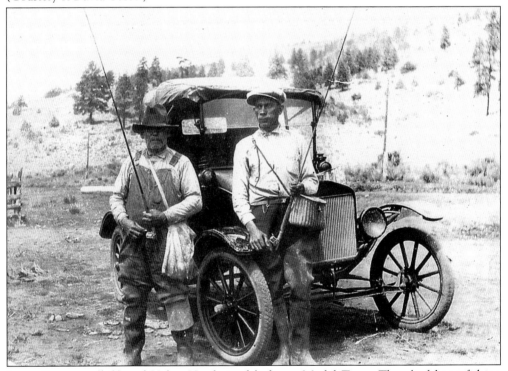

James Patterson (left) and Heber Head stand before a Model T car. They had been fishing together on the Conejos River. Heber, a successful businessman who built bridges, was murdered in 1929. (Courtesy of David Garce.)

Pinckney Head was the son of Confederate soldier Robert Head and Martha Head. He was orphaned by the Civil War in 1863. As a young man, he was baptized into the Mormon faith and joined James Patterson in migration to Colorado. He was partially responsible for keeping the ancient Catawba land claim alive as he sent a number of letters to Washington requesting justice. (Courtesy of David Garce.)

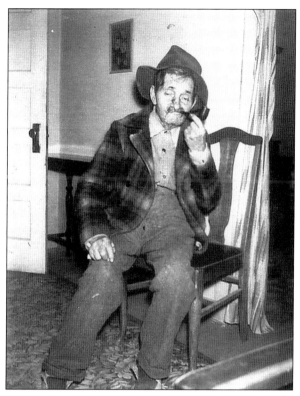

Georgia Henrietta Patterson Canty was the daughter of James and Elizabeth Patterson. She was the wife of John Alonzo Canty. Little is known of Georgia other than that she loved cranberries and she died of yellow jaundice. Georgia Harris of the Catawba Nation of South Carolina was named for her. (Courtesy of Judy Canty Martin.)

John Alonzo Canty was the son of Catawba agent Thomas Whitesides and Eliza Scott Canty. Upon his birth, he took his mother's name rather than that of his white father, something that was commonly done among the Indians. He claimed to be half-brother to Mary Jane Watts and Fannie Harris. John helped run the Catawba Indian Ferry in South Carolina. (Courtesy of Judy Canty Martin.)

Josiah Alexander Harris was born in the Catawba Indian Nation in 1887. He was the son of Hillary Harris and Rachel Tims. Shortly after he was born, the family migrated to Sanford, Colorado. Josiah's father, Hillary, left the family and joined his sister Lillie Harris Ballard in Oklahoma. Josiah had four children: James, Raymond, Evelyn, and Ruby. Raymond became a Mormon patriarch in Durango, Colorado. Josiah is buried in Sanford, Colorado. (Courtesy of Faye Dodds.)

Sarah Ann Canty Evans Head was the widow of Robert Head and the mother of Pinckney Head. She raised Pinckney alone, and while in the West, she married a second Catawba Indian, CSA veteran Alexander Tims. (Courtesy of Judy Canty Martin.)

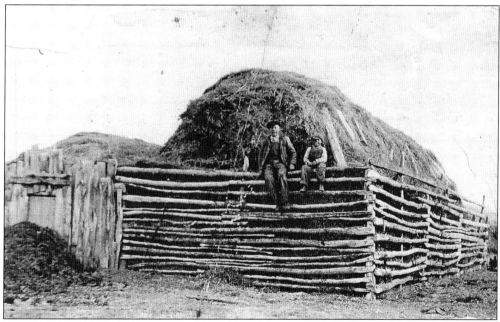

John Alonzo Canty and his youngest son, Alma (Pete) Canty, pose on a haystack. Later Pete became the father of Judy Canty (Martin). John Alonzo was a carpenter by trade. Pete made adobe bricks as a young man. (Courtesy of Judy Canty Martin.)

Guy Garcia (left) is joined by his brother George Garcia (right) in the doorway of a railroad boxcar. They often hitchhiked or jumped a freight train when they wanted to travel. Here they are jumping a boxcar on their way to visit relatives among the Catawba of South Carolina. This photo was taken c. 1935. (Courtesy of David Garce.)

Five of the eight girls born to James and Elizabeth Patterson, pictured here c. 1928, were, from left to right, Maud, Abbie, Dora, Bell, and Martha. They often met in their later years to talk and play cards. When they fished, they blessed the worm on the hook with tobacco juice. They also knew how to "divine" for water. (Courtesy of David Garce.)

William "Buck" Canty (center) is shaking the hand of Kit Carson III. Canty often rode a horse in the Mormon Pioneer Day Parade in Sanford, Colorado, on July 24. His regalia look remarkably like the traditional Catawba regalia. He burned his regalia one day for no apparent reason. This photo was taken in Alamosa, Colorado, c. 1935. (Courtesy of Judy Canty Martin.)

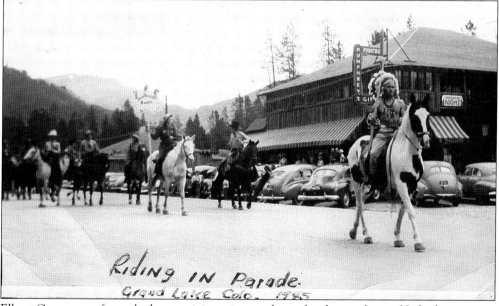

Elbert Garce was often asked to participate in parades and rode on a horse. He had a western-style headdress of eagle feathers, rabbit fur, mink or weasel tails with ribbons, and beadwork. While working in Alaska, he shot a grizzly and made a necklace from the claws. He was often accompanied by his son David Garce. This parade occurred in Grand Lake, Colorado, in 1945. (Courtesy of David Garce.)

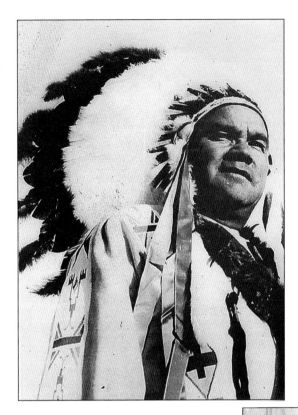

Elbert Garce here poses dressed in his regalia. He was often called upon to speak on the plight of the Indians, family history, and the Catawba Indian Nation. He addressed audiences in universities, high schools, the Rotary, Lions, Elks, Moose, American Legion, and the Veterans of Foreign Wars. He gave well over 450 such talks. (Courtesy of David Garce.)

Elbert Garce joined the army in World War II in 1941. He was promised that as an Indian, he would do no guard duty or KP. He soon discovered that promises made to Indians are not kept and was given guard duty. On one very cold night, he used his Native American ingenuity and abandoned his post, got in a nearby car, turned on the engine, and enjoyed the warmth of the heater. He was injured in training and given a medical discharge in 1942. (Courtesy of David Garce.)

Guy Garcia worked in the Indian Service in 1939. Guy and Elbert Garce were the best of friends. When Elbert obtained a job at Window Rock (Navajo Nation), he sent for Guy to help him. They worked on roads. During this time, the two of them formed a country band called Stubby and the Hillbillies. They played guitar, a jug, the harmonica, and the Jew's harp. Later in life, Guy, who was on the Catawba Roll, was instrumental in forming a drumming team on the reservation. (Courtesy of David Garce.)

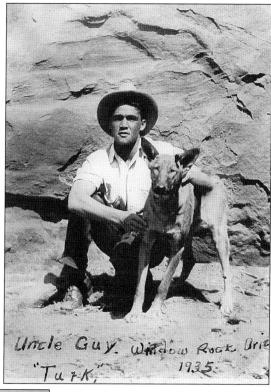

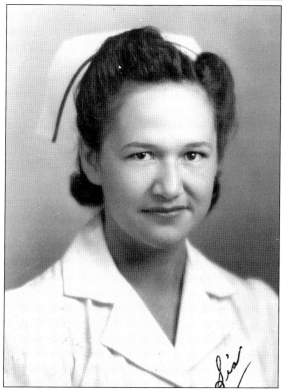

Viola Garcia is the granddaughter of James and Elizabeth Patterson and the daughter of Abbie Allen Patterson and Rufus Garcia. She grew up in the San Luis Valley and in 1937 went to Haskell Institute, a Bureau of Indian Affairs boarding school for Indians. She graduated in 1940 and that same year attended Sage Memorial Nursing School in Ganado, Navajo Nation. As a result, she speaks fluent Navajo. Viola graduated in 1943 and immediately enlisted in the U.S. Army. (Courtesy of Cynthia Walsh.)

59

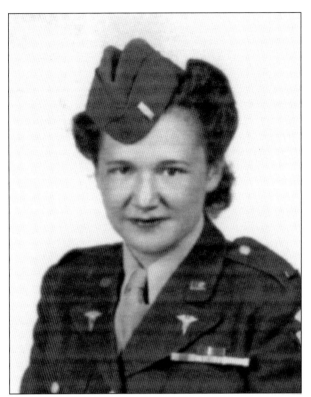

Viola Garcia is pictured here in her World War II uniform. In 1945, she was sent to Japan, where she cared for American military men who had survived Japanese POW camps. While there, she learned to speak Japanese. Later she was transferred to Europe, where she applied her excellent linguistic skills to learning German, French, Italian, and some Russian. Of recent years, she has made several trips to the Catawba Indian Nation to visit her brother Guy Garcia and other family members. (Courtesy of Cynthia Walsh.)

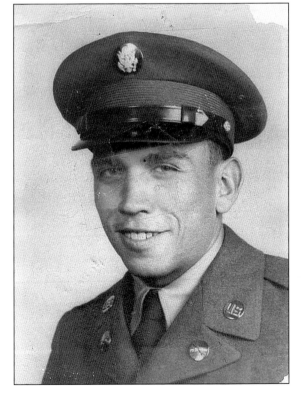

Howard Galvez is the great-grandson of James and Martha Patterson and the grandson of Isabelle (Bell) Patterson. He served in the Korean War and received the Bronze Star for bravery. Today he is retired and lives in La Jara, Colorado. (Courtesy of Judy Canty Martin.)

George Henry Garcia was a grandson of James and Elizabeth Patterson. He was an avid fisherman and could catch a fish with his bare hands. He was also famed for his vegetable garden and left a legacy of generosity as he shared his produce with others. He enjoyed snake hunting and on one day reportedly caught 104 rattle snakes. In the 1930s, he visited the Catawba Indian Nation to spend time with his brothers Guy and Elbert Garcia.

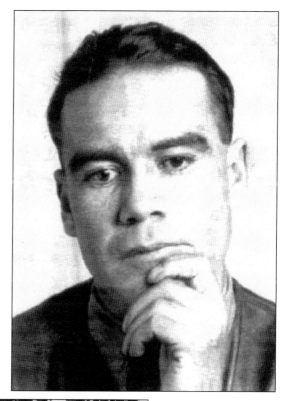

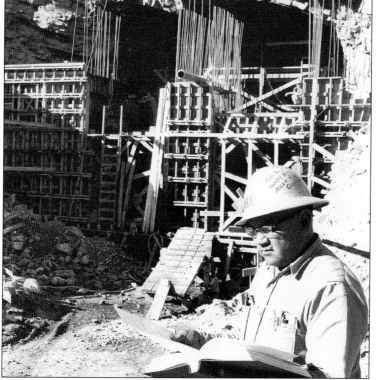

Elbert Garce is here on the job as a Field Inspection Engineer for the Bureau of Reclamation. He worked for the Bureau for 29 years. This job was on the Flaming Gorge Dam. He also worked on Boulder Dam, Nevada; the Shasta Dam, California; the Grand Coolee Dam, Montana; and Blue Mesa Dam, Colorado. He retired in 1969 and died in 2002. (Courtesy of David Garce.)

Abbie Patterson and her husband Rufus Garcia are pictured on their wedding day in 1904. They combined two families from previous marriages and had more children together. Rufus died young and left Abbie to raise a house full of children alone. George Henry Garcia, the oldest, worked to help his mother. (Courtesy of David Garce.)

Judy Canty Martin has been the tribal genealogist for many years. She has self-published the following book-length studies: "Genealogy of the Western Catawba;" "Missionary Journals" of two Mormon missionaries who visited the Catawba during the 1880s; and "My Father's People," a complete genealogy of the Catawba Indian Nation. (Courtesy of Judy Canty Martin.)

Cynthia Walsh, a great granddaughter of James and Elizabeth Patterson, became interested in her Catawba roots early in life. She has visited the Catawba Indian Nation twice. In the summer of 2000, she became webmaster for the Catawba People Page on the Internet (Catawba-People.com). It has become a major source for solid Catawba news. By the summer of 2004, the site had been visited by over 30,000 interested people. She has a Juris Doctorate in Law from the University of New Mexico (Albuquerque) and has worked for the Navajo Nation and Isleta Pueblo. (Courtesy of Cynthia Walsh.)

Wayne Head is a descendant of Confederate volunteer Robert Head and his son Pinckey Head. He lives in Clovis, New Mexico, where he works as a high school counselor. He has a double major bachelor's degree in sociology and social work and has a master's in social work, all from the University of New Mexico. He has visited the Catawba Indian Nation on several occasions. (Courtesy of Judy Canty Martin.)

David Garce, the son of Elbert Garce, has a bachelor of arts degree in landscape architecture and environmental planning from Utah State University. He is a member of the American Council of Architects and Engineers and has worked on projects for the National Museum of the American Indian in Washington, D.C., and various Indian cultural centers, casinos, hospitals, clinics, and resorts. (Courtesy of David Garce.)

Aaron David Garce is the 16-year-old son of David Garce. He attends Hillcrest High School in Midvale, Utah. His interests, aside from his school work, include sports and scouts. He has visited the Catawba Indian Nation to spend time with family and friends. (Courtesy of David Garce.)

Five

THE CATAWBA CULTURE AND ITS REVIVAL

Through their many years of poverty, the Catawba made many of the things they used. These included such things as baskets, rabbit traps, bateau boats, and household items such as brooms to sweep the yard. As the Indians obtained jobs in the cotton mills in Rock Hill and as the river ceased to be a barrier between the reservation and Lancaster County, the Indians began to purchase what they needed. With the construction of the Van Wyck Bridge, they no longer had a need for boats to cross over when such could be done with an automobile over the bridge. When the Catawba Cultural Project was founded by Assistant Chief E. Fred Sanders and his wife Judy Leaming in the early 1990s, crafts of all kinds, including pottery, appeared at the annual Yap Ye Iswa Festival. The Catawba arts and craft revival was under way with startling results.

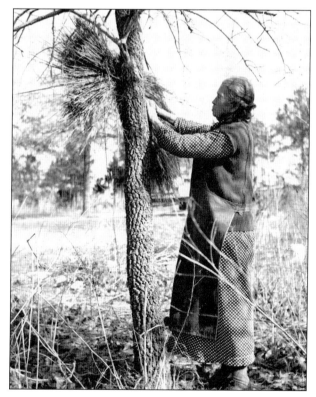

As the last native speaker of the Catawba Language, Sallie Brown Gordon was a source of information regarding all things Catawba. Here she is making a brush broom. These were used every evening to sweep the yard of all infant footprints. If such footprints were left in the dust, the Wild Indians would put a spell on the baby who made them. Such children usually suffered from colic. Clearing the yard before sundown kept this from happening. (Courtesy of the American Philosophical Society.)

Joseph Sanders was another Catawba who was much sought after by all interested in things Catawba. Here he is demonstrating blowing a spiritual medicine into a medicine pot through the use of a river cane tube. Joe was also celebrated for his ability to make Catawba river cane blow guns. On at least one occasion, he made a dugout canoe the old way by hollowing out a single log. (Courtesy of the American Philosophical Society.)

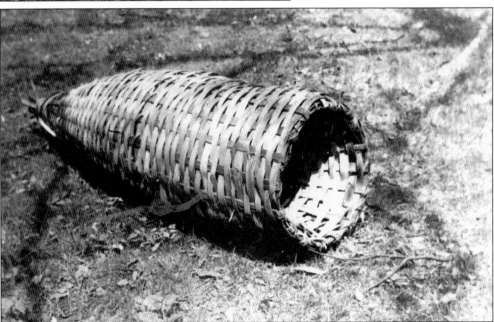

Before the beginning of the 20th century, the Catawba still possessed the skill of making river cane baskets. This photograph of a Catawba split oak basket was found in the Bureau of Indian Affairs (BIA) files. Such baskets were placed in the river's current where fish might swim in to take bait. Once inside, escape was nearly impossible. By the 20th century, the Catawba had resorted to trot lines, which were strung across the river and checked every day. (Courtesy of the Bureau of Indian Affairs.)

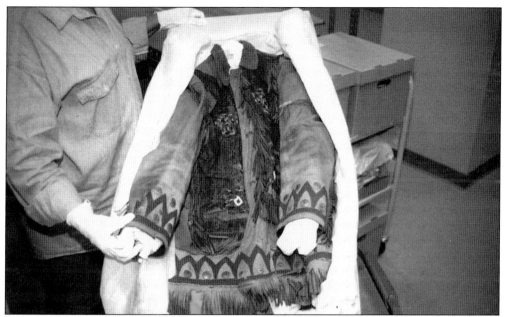

One of the earliest gifts received by the Catawba Nation Archives when it opened in 1995 was this regalia once worn by Chief Samuel T. Blue. Today it is stored in an acid-free box. When brought out for study, Archivist Billie Anne Canty McKellar uses gloves to protect these fragile items of apparel. The archives collects and stores materials relating to Catawba history. These materials include photographs, folk histories, and records such as the BIA files from 1941 to 1961. (Courtesy of Steve McKellar.)

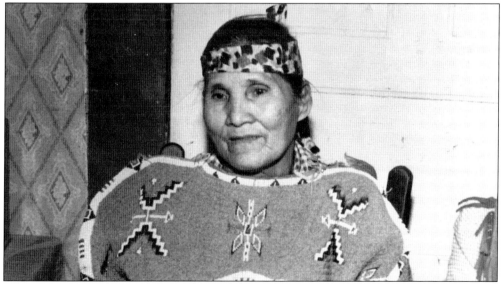

During the 20th century, the wearing of Indian regalia was nearly lost among the Catawba. Since Louisa Canty Blue was married to a man who was chief for a number of years and retained his popularity even when he was not chief, she had many occasions to wear regalia for important reservation visitors. In today's revival of all things cultural, such regalia are dressed with original bead work. Original work is most often seen at the Yap Ye Iswa Festival and at other historical events. (Courtesy of the Bureau of Indian Affairs.)

The Catawba men love to hunt. In this photograph, Howard George, left, proudly exhibits a whitetail deer he had shot on October 25, 1970. His friend Bonnie Lucas is on the right. (Courtesy of Howard George.)

Shortly after Martha Jane Harris developed the practice of straining clay to remove impurities, a second unknown inventor built the first formal strainer of wood and window wire. Martha Jane merely stretched her wire over a hole in the ground lined with old sheets; the excess water seeped through. Fletcher Beck built his wife, Sallie Beck, this strainer, which she used for many years. This type of strainer is suspended over a bucket, and the clay is caught inside where it dries. Such strainers remain in use today.

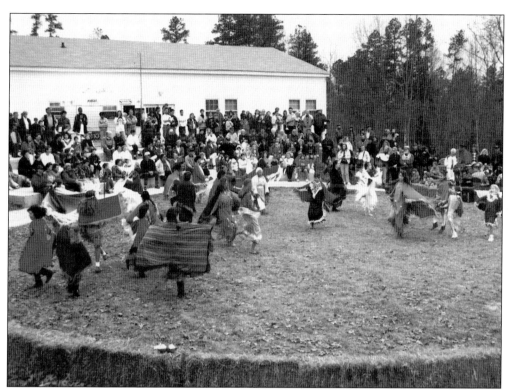

One of the most dramatic results of the cultural revival is Catawba dance. The first dancers were Evelyn George, Blanche Bryson, Elizabeth Plyler, and a few others who could remember the old steps. One of the many ancient dances revived is the Wild Goose Dance. Here a group of women dance in a V formation in imitation of geese. A lone male dances, searching the sky for the geese. When he spots some, he fires his gun into the air. The women dancers flutter in confusion and exit the dance circle.

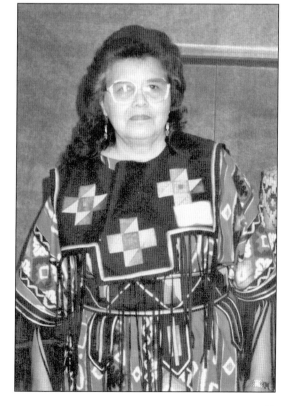

Elizabeth Plyler was one of the founders of the first Catawba dance troop in the late 1980s. She is wearing one of her finest dance dresses at the Yap Ye Iswa Festival. Elizabeth Plyler is also a master potter of note. From the beginning she has been a leader in all aspects of the cultural revival and is a traditionalist. (Courtesy of Steve McKellar.)

Faye Robbins Lear was a spiritualist within the tribe. She claimed to have seen the Wild Indians. She also made regalia and sold her products at pow wows in both Carolinas. Before she died, Faye had decided to produce the 1913 women's regalia for sale. She never lived to accomplish this dream. (Courtesy of Earl Robbins.)

Dean Canty is shown here in a traditional ribbon shirt at the 1994 Yap Ye Iswa Festival. The ribbon shirt was revived since it is standard men's wear throughout the Southeast. Dean is a lead male dancer and often dances the male part in the Wild Goose Dance. He has written songs in both Catawba and English. (Courtesy of Steve McKellar.)

Monty Branham has been a leader in the cultural revival since its beginning. He is a master potter of great skill and makes vessels as small a smoking pipes and as large as storage vessels. He is also a primary flute maker and has conducted workshops of the making and tuning of river cane flutes. He makes drums, from the small hand-held drum to the large communal drums. He has written music in both English and Catawba and composes on the flute. In this portrait, he is wearing a ribbon shirt. (Courtesy of Steve McKellar.)

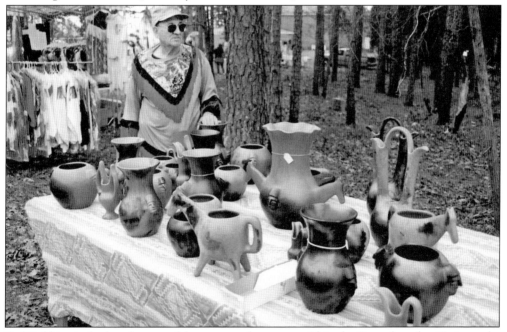

Earl Robbins is the best known of the many male potters within the Catawba tribe. He is sought out for his large pieces, particularly his monumental snake pots. This photo was taken during the 1994 Yap Ye Iswa Festival. The pottery on display belonged to Earl. He usually sells out when he attends any historical event and offers his wares. His shirt was made by his sister, Faye Lear. (Courtesy of Steve McKellar.)

Anna Brown is a leader in the women's cultural revival, particularly the dance. She is a great-granddaughter of Sallie Gordon and a bead worker of great skill. Anna has been studying the Catawba language for many years and is somewhat of a speaker. She has taught Catawba vocabulary to children at the Catawba Head Start and Red Path Baptist Church. (Courtesy of Anna Brown.)

Walter Harris is a potter who works in the tradition of his mother, Reola Harris. Here he is selling his wares at the 1994 Yap Ye Iswa Festival. His shirt was made by his aunt, Faye Lear. Recently, he has taken up the craft of flint knapping. (Courtesy of Steve McKellar.)

Freddie Sanders is a traditionalist Catawba who was one of the primary leaders in the men's dance revival. He is wearing pan-Indian regalia of his own make. A master potter of great skill, he occasionally makes Catawba shapes in soapstone. (Courtesy of Steve McKellar.)

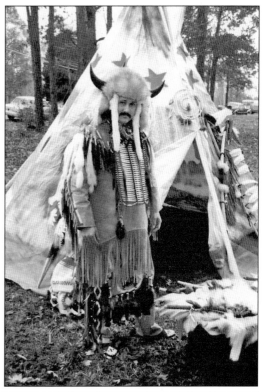

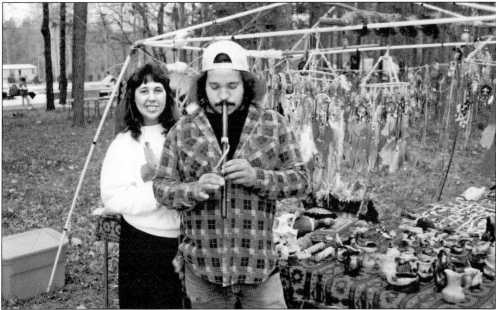

Warren Brian Sanders is a master potter of note. He makes river cane flutes, one of which he is playing at the 1994 Yap Ye Iswa Festival. His master potter wife, Cheryl Harris Sanders, looks on in the back. For several years, the Sanders family followed the pow wow circuit. Today they continue to provide a wide assortment of pottery and other crafts to museum shops. (Courtesy of Steve McKellar.)

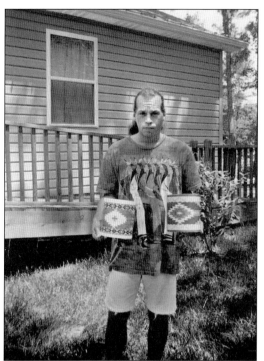

Monty Branham, as a result of his great interest in music, has provided drums to many Catawbas. Here he is working on hand drums which he will sell, trade, or give to fellow Catawbas who have a need for a drum. (Courtesy of Monty Branham.)

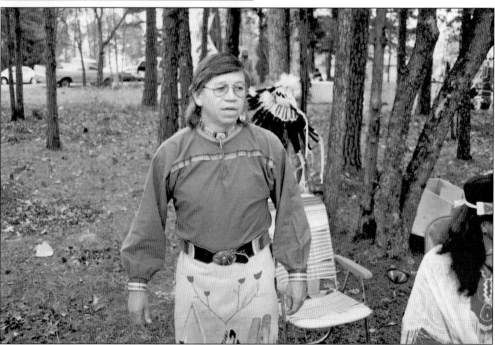

Keith Brown is a man of many skills, including those of a master potter. Through his work in the Exhibits Department of the cultural center, he has frequently spoken before audiences on Catawba culture. He always receives rave reviews and is much sought after as a speaker. He was a leader in the revival of the Sweat Lodge and remains active in the sweat. He is wearing a traditional ribbon shirt. (Courtesy of Steve McKellar.)

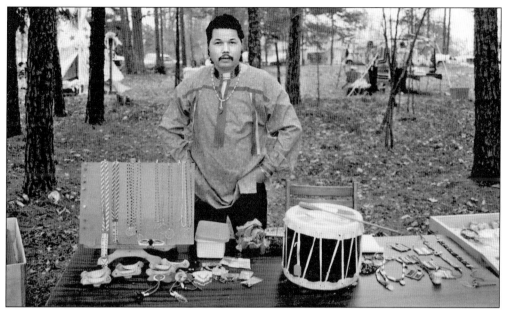

Charlie George, a grandson of Evelyn George, attended the 1994 Yap Ye Iswa Festival to sell his arts and crafts. He is wearing a traditional ribbon shirt. He served in the U.S. Navy for 11 years and currently lives in Jacksonville, Florida, where he works for Amvets. (Courtesy of Steve McKellar.)

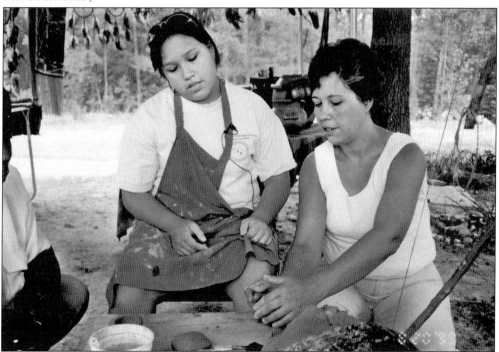

Miranda Leach is receiving traditional pottery-making lessons from her mother, Cheryl Harris Sanders. Although the Catawba have held formal classes in pottery making since 1976, for tribal members only, most teaching of this craft is conducted within family circles. A student like Miranda must learn fixed building techniques for over 100 pottery shapes.

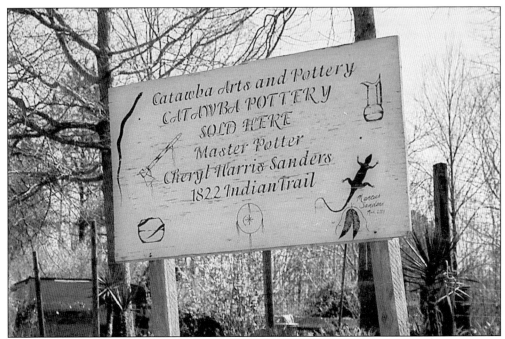

Some of the potters resort to road signs to advertise their pottery. This sign belongs to Cheryl Harris Sanders and was made for her by Marcus Sanders, brother of Brian Sanders. The sign displays several common and most sought-after pottery motifs. The two feathers in the lower right corner constitute Marcus Sanders's signature.

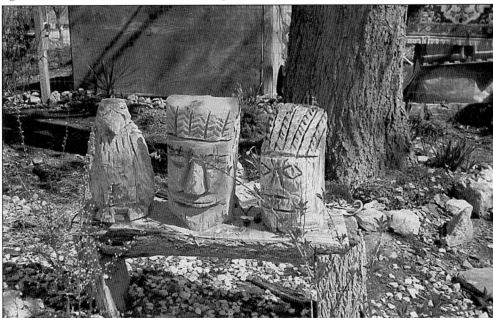

Warren Brian Sanders is celebrated for a wide variety of arts and crafts, including dream catchers, wooden objects with burned designs, walking sticks, and pottery made at the master's level. On occasion, he makes objects such as these with a chain saw. These examples decorate his yard on Indian Trail.

In 1913, when the Catawba women attended the Corn Exposition in Columbia, they wore this regalia. The dresses showed the memory of the war captain rank once held by both men and women. War captains had the right to wear the black snake on their bodies in tattoo form. Today's snake pots and pipes are a recollection of this insignia and rank. Here the black snake decorates the bodice of the dress.

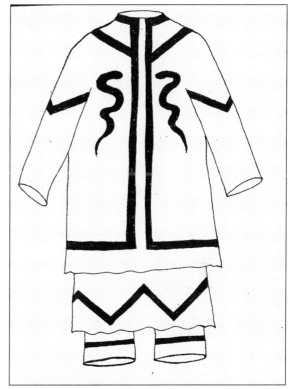

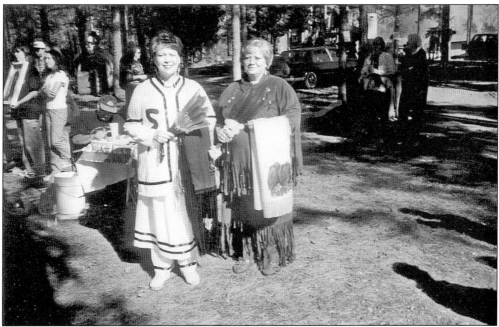

The snake dress has experienced a modest revival since the early 1990s. Teresa Harris wears such a dress of her own make at the annual Yap Ye Iswa Festival when she joins the women's dance troop. She wore this dress in a 2003 Rock Hill ethnic beauty pageant. To her right is her sister Loretta Harris. (Courtesy of Teresa Harris.)

Anna Brown is celebrated for her bead work. Here she is at the 1996 Smithsonian Folklife Festival displaying a beaded belt she had recently made. Her work is much sought out by her fellow Catawba and is often used to decorate regalia.

Elsie Blue George was the winner of a senior beauty pageant held in 1997 in Rock Hill. She was best in the evening gown competition. The other two categories included talent and stage presence. As a young girl, she served as teacher's helper in the Catawba Indian School. She is the widow of Landrum George. (Courtesy of Joann George Bauer.)

Leonard Chadwick George, better known on the reservation as Chad, helped to found the young boys' dance troupe for the Catawba Cultural Center. He is a regular dancer at the annual Yap Ye Iswa Festival. This photo was taken at the 1994 festival. (Photo by Steve McKellar; courtesy of Wayne George.)

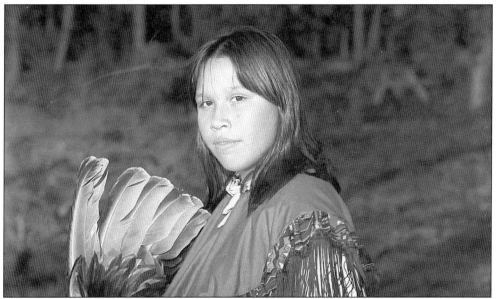
Miranda Leach for many years was a frequent contestant at pow wows in both Carolinas. She was often a winner. Today she has retired to care for her newborn son, Kevin, who will most likely be a feature dancer at the Yap Ye Iswa as soon as his mother can teach him the steps and his grandparents Brian and Cheryl Sanders can get to work on his regalia. (Courtesy of Warren Brian Sanders.)

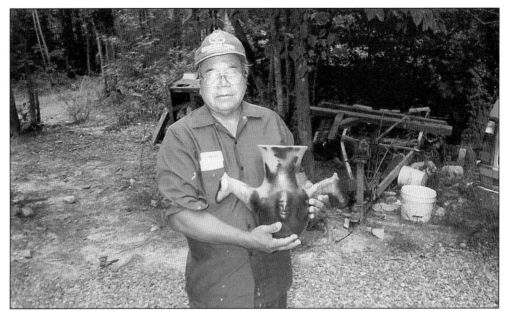

E. Fred Sanders is a longtime member of the Catawba Nation's executive committee and helped steer the Nation through its 1993 Settlement. He resigned over the loss of many jurisdictional issues. In 2002, Fred came out of retirement and was elected to the Chief Bill Harris Executive Committee as councilman. Here he has just purchased one of Earl Robbins's crazy horse pots. Today many of the Catawba are proud owners of extensive collections of Catawba pottery. (Courtesy of Earl Robbins.)

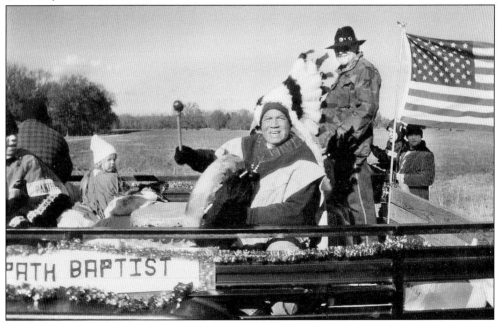

Howard George is a member of the newly founded Red Path Baptist Church. This Christmas parade was in Lowrys, South Carolina, in 2003. He is wearing his plains-style war bonnet and beating on a large communal drum. Different culturally active Catawbas are often asked to be featured participants in parades throughout both Carolinas. (Courtesy of Howard George.)

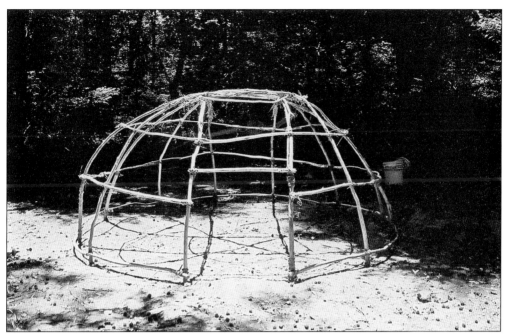

The Sweat Lodge and its related ceremonies, usually performed during the full moon, were revived among the Catawba in 1995. Those involved in this effort included Keith Brown, Rocky Simmers, and tribal medicine man John George. Several lodges are maintained, including at least one for women. This lodge was crushed during a freak 2004 snowstorm. Keith Brown rebuilt the frame, which is ready to be covered with blankets.

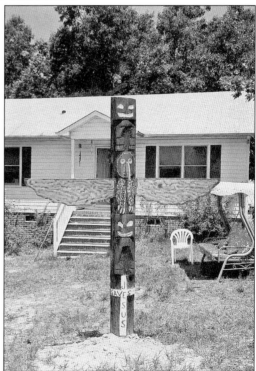

The totem pole is not part of Catawba culture, but Howard George took a notion one day to carve one that would speak of his admiration for his culture. It was constructed early in 2004 and is the frequent subject of photographers who visit the reservation.

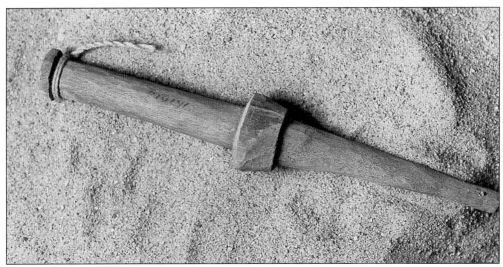

This piece of utilitarian wood carving is a stick made to bore out pipe stems and to cut holes in vessels intended to have Indian head lugs or handles. To attach any appendage, the Catawba insert the object through the vessel's walls to add strength. Today, most of the Catawba use any stick or small knife to accomplish this task.

The undisputed master of pottery demonstrations is Nola Harris Campbell. Time and time again, spellbound audiences stood and watched Nola quickly construct large cooking pots and water jugs. Nola demolished her work at the end of each session. She always enlisted one or two children in this task, which brought gasps of horror from her admiring audience. Here Mat Stanley (right) and Austen Powers (left) are in the process of destroying one of Nola's masterpieces. (Courtesy of Tom Stanley.)

Six

NEW RESERVATION

When the Catawba gained recognition from the Federal Government and came under the Bureau of Indian Affairs (BIA) in 1941, a new era began. The Bureau of Indian Affairs pushed local businessmen to accept the Catawba as workers. When the Catawba children finished at the Catawba Indian School they went to white schools in York County and Rock Hill. The old school was abandoned for a more modern school capable of taking the expanding population. All concerned knew that the Old Reservation could not handle a growing tribe, and additional lands called the New Reservation were purchased. Immediate problems surfaced as the Indians refused to move off the Old Reservation. The Mormon Church and the cemetery was early in the move. Families followed reluctantly at first and then with an attitude that might have approached zeal. New houses were built. Some of them looked little different from the Old Reservation dwellings, but they were more modern and had more rooms.

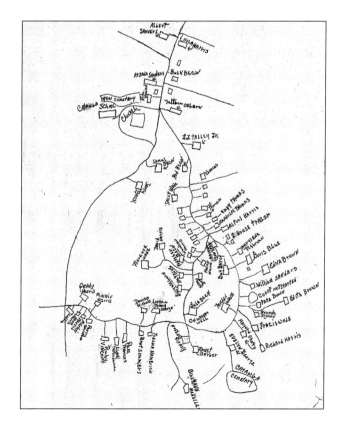

Dennis Bryson, the husband of master potter Louise Beck, drew a map of the Old Reservation, c. 1979. Houses clustered around the church, the cemetery, and the new school are on New Reservation land, which was in various tracks from this point to the outskirts of Rock Hill. By the time Dennis drew this map, large numbers of traditional Catawba had begun to ask for and receive land allotments on the Old Reservation. (Courtesy of Dennis Bryson.)

83

The Cattle Project received much publicity during the early Federal Wardship period. The project began in 1950 with a $10,000 outlay of funds to purchase cattle. The project ended in 1960 with Termination. The cattle were sold and each Catawba received $10 as his share of the money from this sale. Today we can look back and see how very little the Catawba received from Termination. In 1960, tribal members could not see how much they were losing. (Courtesy of the Bureau of Indian Affairs.)

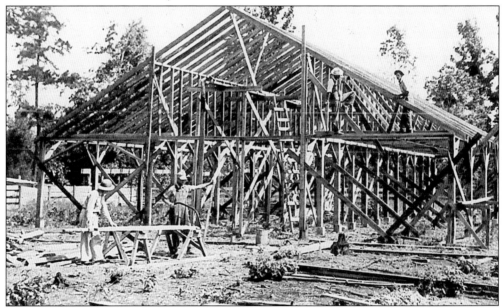

If one contrasts this cattle barn with that proudly displayed by Samuel T. Blue (page 28), we can get a better understanding of the tremendous advances made during the Federal Wardship. This modern barn had stalls for cattle and room for hay and was also used to store machinery. It burned in the 1980s. (Courtesy of the Bureau of Indian Affairs.)

Marvin George agreed to move his family from cramped quarters on the Old Reservation to a tract at Red River much closer to work in Rock Hill. The house had four rooms: a living room, two bedrooms, and a kitchen. Shown in the doorway are, from left to right, his wife, Evelyn George; and three of their children, Phillip, John, and Susan. (Courtesy of the Bureau of Indian Affairs.)

Earl Robbins also agreed to move his family to Red River. The Robbinses' home was built from lumber taken from an old barn. Originally, it had two rooms. Earl later expanded the house to include more room and to accommodate his family more comfortably. Bruce Robbins, a child who died soon after this picture was taken, plays in the yard. Viola Robbins stands in the doorway, and her mother, Maggie Price Harris, is to her right. (Courtesy of the American Philosophical Society.)

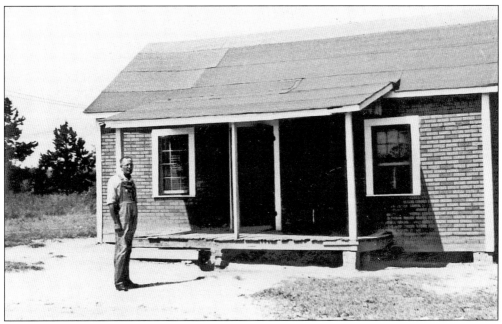

This dwelling was constructed on the New Reservation by John Idle Sanders around 1946. It consists of four rooms and a porch. Idle died here and his wife, Arzada, lived here until she needed help in managing her affairs. Today the house still stands but is unoccupied. (Courtesy of the Bureau of Indian Affairs.)

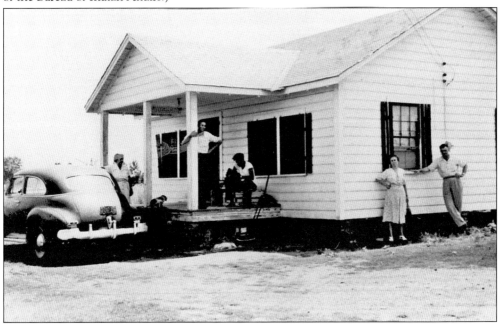

Dewey Harris built this house on New Reservation land. After Dewey left the area, he gave his mother, Georgia Harris, the right to live there. After the pottery revival that began in 1973, Georgia constructed most of her pottery here. In the ditch between the house and the road, Georgia located a pan clay source. In spite of this fact, she continued to use pan clay from the Blue Clay Hole in Lancaster County. (Courtesy of the Bureau of Indian Affairs.)

The former home of Louise Beck and her husband, Dennis Bryson, stands on the site of the old stucco Mormon church. Some of this house rests on the church foundation and is located on the corner of Tom Steven Road and Indian Trail. Louise Bryson ran her pottery business from this house from 1976 to her death in 1984.

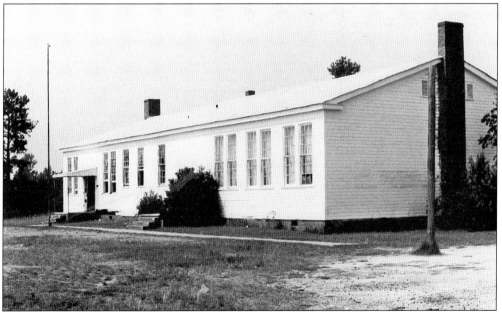

The much expanded Catawba Indian School was built under the leadership of Chief Raymond Harris in 1948 when land was set aside for the purpose of a new and larger school. Money was appropriated in 1949. The building was constructed by the J. Roy Neely Construction Co. and completed during the summer of 1949. The first classes were held that fall. A baseball diamond was added to the schoolyard in 1953 by Chief Ephriam George. (Courtesy of the Bureau of Indian Affairs.)

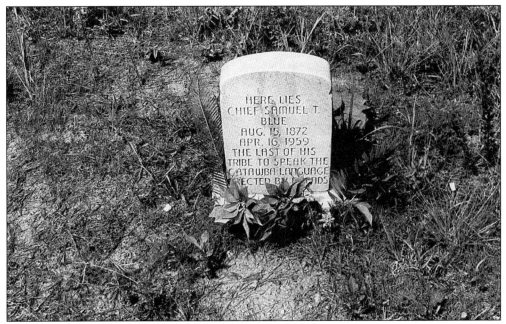

When the Catawba Indians built a new Mormon church on New Reservation land, a cemetery was mapped out behind the church and the adjacent school. This cemetery replaced that located at the end of Cemetery Road, which had run out of room for burials. This new cemetery is still in use by Catawbas of all faiths.

After E. Fred Sanders (also seen on page 43) returned home from the military, he took up the trade of barber. He attended the Salt Lake City Vocational School from 1961 to 1962. He returned to South Carolina in 1964. For a time, he worked at the Thomas Barber Shop in Rock Hill. He is at the center of the photograph. (Courtesy of E. Fred Sanders.)

This Mormon chapel was built in 1952 to replace makeshift quarters used since the Mormon Stucco Church had become unusable. It was used by the community until 1985, when it was replaced by a new and larger structure.

In 1987, this author published his *Bibliography of the Catawba* to assist the Indians and their lawyers in the land issue Settlement of 1993, providing tribal attorneys with much needed references. The tribe presented copies to Sen. Strom Thurmond, Sen. Ernest Hollings, and Congressman John Spratt. Here Thomas Blumer and Chief Gilbert Blue present a copy to Senator Thurmond. (Courtesy of the U.S. Senate.)

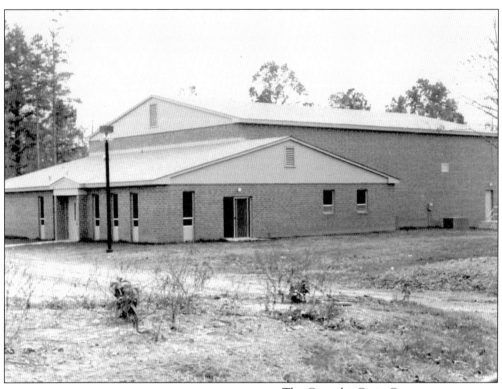

The Catawba Civic Center was constructed in 1978 under the supervision of the tribe's secretary/treasurer, Samuel Beck. It was originally used for basketball games and dances. During the early years of the Yap Ye Iswa Festival, it was used to house craftsmen during stormy weather. Today it houses the Catawba Head Start program run by Ellen Canty Bridges and her husband, Robert.

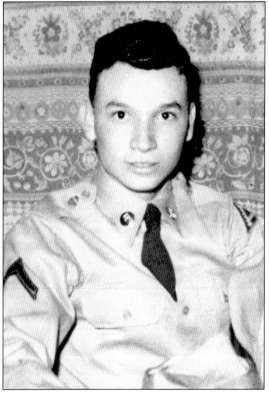

Carl Harris was the son of Chief Raymond Harris and his wife, Nola. Carl died in Vietnam in 1965 and is buried in the New Reservation Cemetery behind the Mormon church. He was survived by his widow, Anne Harris of Dothan, Alabama, and one son, Carl Harris Jr. Carl's name is inscribed on the Vietnam Memorial Wall in Washington, D.C., along with that of Gerold R. Simmers, who also died in the war. (Courtesy of the late Nola Harris Campbell.)

During the Termination Period (1959), the Catawba were encouraged to take up trades and perhaps start businesses of their own. Sara Lee Ayers and her husband, Hazel Ayers, used this modest building as a pottery shop. It failed for a lack of support from the potters, most of whom had taken jobs in the local cotton mills. Today it is a storage shed in Fred Sanders's yard on Reservation Road.

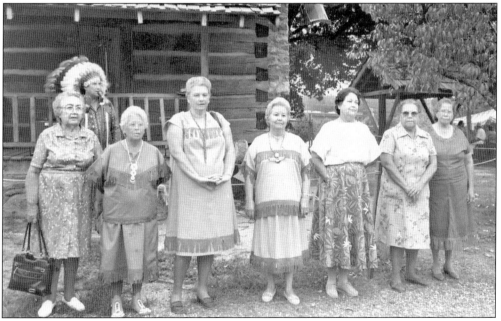

Of all the various museums located in both Carolinas, none has done more to promote the Catawba Indian potters than the Schiele Museum of Natural History in Gastonia, North Carolina. This 1987 photograph shows a number of potters who belonged to the Catawba Potters' Association, from left to right: Georgia Harris, Evelyn George, Nola Harris Campbell, Helen Beck, Frances Wade, Mildred Blue, and Catherine Canty. Chief Gilbert Blue stands behind Georgia Harris. (Photograph by Michael Eldridge; courtesy of the Schiele Museum.)

Frances Wade stands to the left with her aunt Edith Brown. Frances Wade has been one of this author's tribal mentors from 1976 to the present. At this time, she was busy founding the Catawba Indian Potters' Association in conjunction with Doris Blue and Georgia Harris. The association served the potters from 1976 to 1993. When this picture was taken, Edith Brown was the senior Catawba potter.

After Earl Robbins resumed making pottery in 1986, he built this pottery shop where he could show his pottery to prospective buyers. At first, the shop was used to house and show Earl and Viola Robbins's pottery. Today their daughter Margaret Robbins has joined the family pottery business and uses the shop to display her wares. The occasional pottery of Matthew Tucker and Paige Childress may also be found in Earl's pottery shop.

The Catawba Cultural Preservation Project is housed in the Catawba Indian School, which was moved from beside the Mormon church to Tom Steven Road in 1990. It houses the project office, a Catawba arts and crafts shop, and the Catawba Nation Archives. The old school auditorium is used for wedding receptions and birthday parties along with cultural events. Revolving exhibits illustrating Catawba history and culture are found in the lobby. The cultural center is also central to the annual Yap Ye Iswa Festival.

In 1998, the Catawba Indian Nation launched its major business enterprise, a bingo hall located on Cherry Road in Rock Hill. This venture has caused much debate and friction within the tribe since it has generated very little money for the tribe or its members. According to the Traditionalist Faction and others, the little money earned has evaporated and brought few or no benefits to the tribe.

Over the last few years, existing reservation housing has been improved considerably. This house, located on Indian Trail, was built by Guy Garcia and Betty Blue Garcia in 1951. It was constructed with tribal labor. Many of the Catawba men know how to build houses.

Perhaps one of the most interesting dwellings on the reservation is a makeshift affair built by Bruce Wade, who lives there today. He makes pottery and works in soapstone when he is not doing construction work. Here we see the outer wall and gate located between the house and Cemetery Road.

Seven
Catawba Potters' Hall of Fame

Without the Catawba potters who worked so hard in clay for so very little money from the American Revolution to World War II, there would be no Catawba Indian Nation today. They kept the community fed and clothed, particularly in times of stress. Such a period was during the War Between the States (1862–1865) when all the able bodied men served in the Confederate States Army. At the end of the War the Catawba, like everyone else in Dixie, suffered the deprivations of Reconstruction. They faced this crisis nearly alone for few of their men came home in 1865 able to work. When Reconstruction ended in 1877, some of the pressure was off. New young men went out to work as day laborers on farm and to cut cord wood, but the potters staved off hunger by producing a steady supply of pots. The best of these men and women and those who have joined the today, through their excellent artistic skills, and celebrated here.

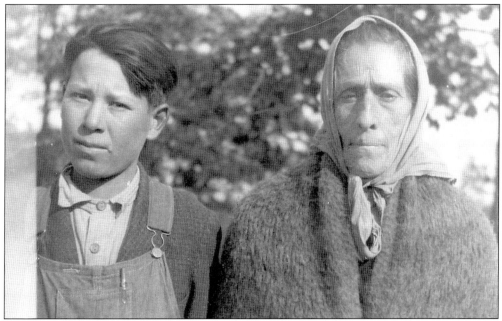

Martha Jane Harris (1860–1936) is without a doubt the most revered potter in today's Catawba community. She is particularly known for her very large Indian head pots. She also served her community in other ways with pride. She was also a midwife and laid out the dead. (Courtesy of Georgia Harris.)

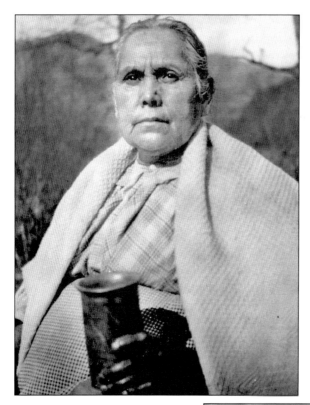

Susannah Harris Owl (1837–1934), the daughter of Rhoda Harris, comes in second after Martha Jane only because she spent most of her life among the Cherokee Indians. Every major collection possesses some of her work; it is identified as hers by records. One of her favorite forms was the traditional snake pot. She was popular among linguists, particularly Frank G. Speck, and spoke Catawba all her life. Susannah is credited with starting the North Carolina mountain trade with her husband, Sampson Owl. She made many small pieces for this trade. (Courtesy of the National Museum of the American Indian.)

Absolom (Epp) Harris (1830–1916) was the husband of Martha Jane Harris. He was one of the finest pipe makers the 19th century ever produced. He liked to ramble and spent time among the Pamunkey in Virginia and the Cherokee of North Carolina. His influence is still felt at Pamunkey. His pipe molds or copies of them are still used by contemporary Catawba potters. His most famous shape was the boot pipe. (Courtesy of the National Museum of the American Indian.)

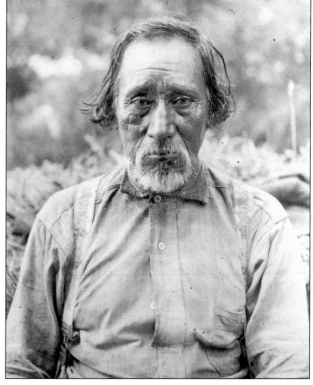

Nettie Harris Owl Harris (1872–1923) was the granddaughter of Rhoda Harris. She married into the Cherokee Nation and spent most of her life there. She put all of her children through Indian schools through her pottery sales. Much of her pottery was made for the North Carolina mountain trade, and she sold through her Uncle Sampson's tourist shop. All of her work is of museum quality. Late in life, she married Robert Lee Harris, who was a potter in his own right. (Courtesy of the National Museum of the American Indian.)

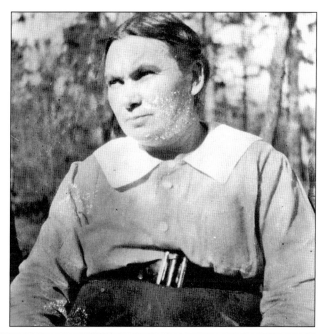

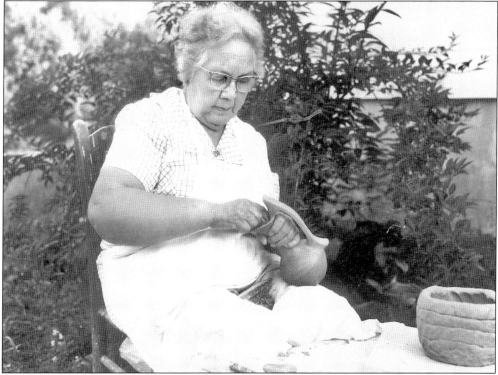

Georgia Harris (1905–1997) was the most honored Catawba potter of the 20th century. She posthumously received the coveted National Heritage Fellowship Award from the National Endowment for the Arts in 1997. Georgia learned to build pottery from the best teacher possible, Martha Jane Harris, her grandmother. Her work is found in every major collection. (Courtesy of Steve Richmond, Indian Arts and Crafts, Bureau of Indian Affairs.)

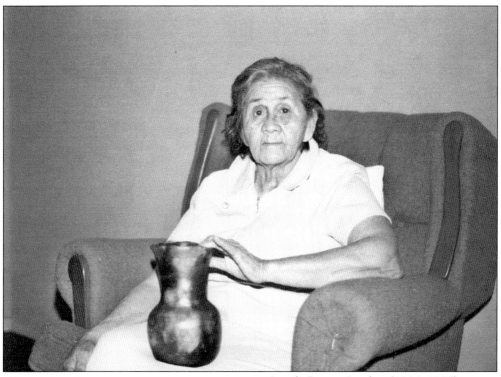

Arzada Brown Sanders (1896–1985) was a much beloved potter who worked in clay constantly and did not retire until failing health became a requirement. She was the daughter of John and Rachel Brown and credited her work as being influenced most of all by them. She only began to sign her work in the early 1970s. Even so, much of her work is easily identified by the very faint feather motif she often used.

Doris Wheelock Blue (1905–1985) learned to make pottery from her mother, Rosie Wheelock. Her flawless work was much respected by collectors and her fellow Catawbas. She began to sign her work in the early 1970s. Also during this period, she began to venture into larger forms. Before this, she concentrated much of the time on pipes and small effigies, all finished to perfection and most incised with traditional Catawba markings. She shunned the North Carolina mountain trade as demeaning. She also refused to teach in the Class of 1976 because the man over the class was not an Indian. (Courtesy of Betty Blue Garcia.)

Edith Harris Brown (1893–1985) grew up watching her grandmother Sara Ayers Harris make pottery, and she just absorbed the tradition. When she married and had her own family, she began to work in clay. She also worked on farms doing day labor and made pottery when time permitted. After the revival of the 1970s, she worked almost constantly in clay. She was assisted in digging clay and burning pottery by her family.

Emma Harris Canty Brown (1889–1961) was a potter of great influence. She was the lead potter at Schoenbrun, Ohio, where a group of Indians finished pottery under her supervision. Here she is working up some clay at Schoenbrun. One of Evelyn George's children watches. Emma made a large range of vessels and was known for her Rebecca pitchers and peace pipes. After her marriage to Early Brown, he always assisted her, scraping her pots and signing them with her name. (Courtesy of Evelyn George.)

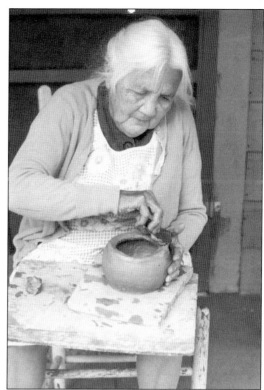

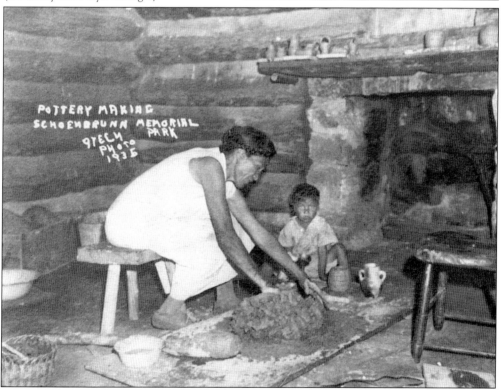

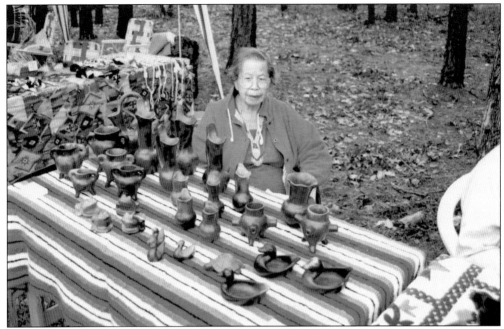

Catherine Sanders Canty (1917–1999) was the daughter of Arzada Sanders. Though she grew up watching her mother work in clay, she did not start herself until she married. Then she worked with her mother-in-law, Emma Brown. Her Rebecca pitchers are exact copies of those made by Emma. She generously taught pottery in the tutorial system and was an inspiration to all the young potters, especially her daughter Billie Ann Canty McKellar. She was known for her frog effigies and her nontraditional rat pots, which she sold as fast as she could build and burn them.

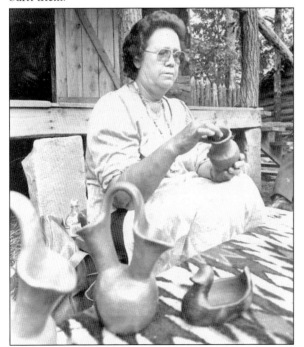

Sara Lee Harris Sanders Ayers (1919–2002) was one of the most prolific potters of the 20th century. Her work is still avidly sought after by collectors and brings high prices on the market. She and her husband, Hazel Ayers, sold her work from New York to Atlanta. She often worked for the Schiele Museum of Natural History in Gastonia, North Carolina, as she is doing here. That museum has a large collection of her work. (Courtesy of Gene Crediford.)

Evelyn Brown George is one of the most generous potters the Catawba Indian Nation ever produced. She received the Jean Laney Harris Legislative Award from South Carolina for her contributions in 2004. She gave pottery tutorials and has never been afraid to ask a fellow potter, young and old, for advice. She was also a leader in the revival of Catawba dance in the 1990s.

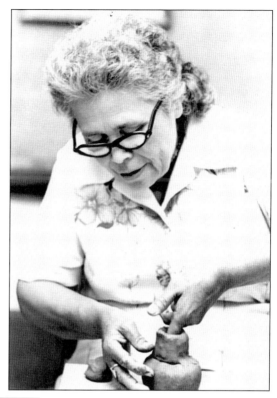

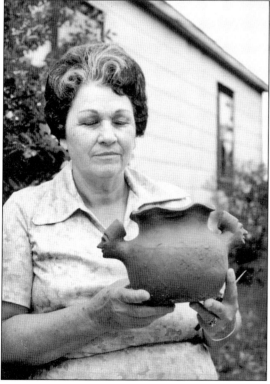

Nola Harris Harris Campbell (1919–2001) was one of the most celebrated potters of the 20th century. She was a generous teacher and the most accomplished pottery demonstrator in Catawba history. I asked her one time how long it would take her to sell a fire full of pottery worth several thousand dollars and she said with confidence, "A couple telephone calls."

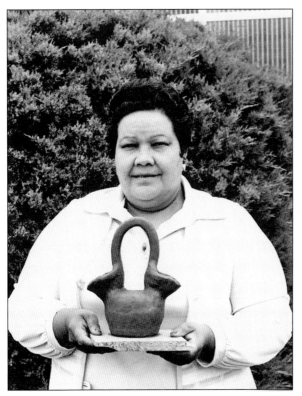

Alberta Canty Ferrell (1929–1998) was an independent potter who often worked with her aunt Isabelle George and her cousin Martin Harris to produce ware for the North Carolina mountain trade and South Carolina beaches. She returned to working in clay after a number of years of retirement to sell at the Yap Ye Iswa Festival. She owned a pair of pipe molds made by Martha Jane Harris or Marvin George.

Sallie Brown Beck (1893–1993) reflected the tremendous work done by her parents, Rachel and John Brown. She most likely introduced the wedding jug into the Catawba tradition. Chances are she learned to make the shape from her mother-in-law, Lillie Beck Sanders Bryson, who must have learned from her Cherokee neighbor Rebecca Youngbird. She taught for the Class of 1976 and this event brought her out of retirement.

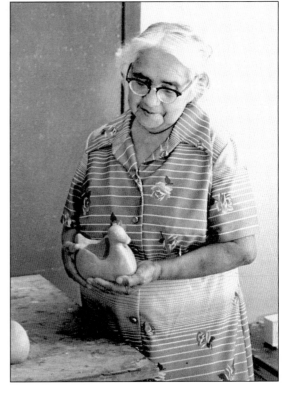

Viola Harris Robbins has produced pottery during her entire adult life without a moment of retirement. She produces a high-quality North Carolina mountain trade ware. She sells out of her husband's shop at home and also attends historical fairs. In 2004, she and her husband, Earl Robbins, were honored with the Keeper of the Culture Award from the Museum of York County. She is willing to teach but her major student is her daughter Margaret Robbins.

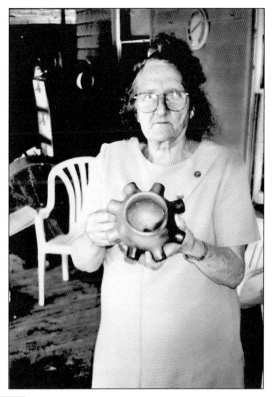

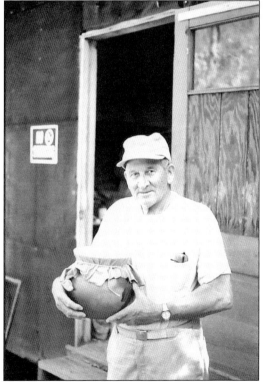

Earl Robbins is the most celebrated male potter. He is best known for monumental pieces, especially his large snake pots. In 2004, he and his wife, Viola, were honored with the Keeper of the Culture Award from the Museum of York County. Here, he proudly shows off one of his traditional pot drums.

Bertha Harris grew up watching her elders make pottery. After her marriage to Furman Harris, the couple lived with Furman's grandmother Martha Jane Harris. She came under Martha Jane's influence during this period. She also kept a close relationship with her sister-in-law Georgia Harris, and the two often made pottery together. She demonstrated pottery making for the Mormon church. She retired for a number of years and returned to her clay following the Class of 1976, taking full advantage of the more equitable prices.

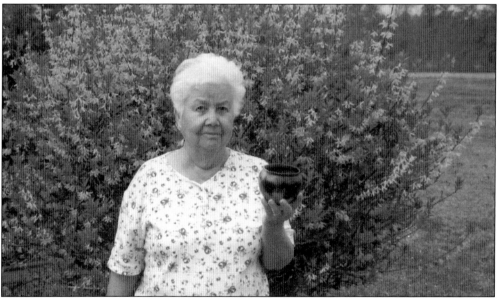

Helen Canty Beck learned to make pottery from her mother, Fannie Harris Canty George, during the height of the North Carolina mountain trade, when Fannie took a carload of pottery to the mountain every week. The family maintained a sort of assembly line, and Helen was part of this effort. Here she is pictured with a bowl she made at age 11. She took advantage of the 1970s revival. She also worked with her mother-in-law, Sallie Beck.

Louise Beck Bryson (1931–1984) was a ray of sunshine on the Catawba tradition. She grew up watching her mother, Lula Blue Beck, make pottery but was never allowed to waste her mother's clay. She took part in the Class of 1976 and immediately showed great talent. She had such a personality that everyone who visited her home to buy pottery went away happy with the vessel and the experience of Louise's keen sense of humor. Once, she broke a fine pitcher and salvaged it by telling the happy collector he had a "Catawba bed pan."

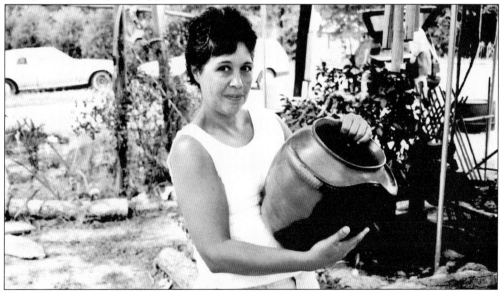

Cheryl Harris Sanders is the wonder of the Catawba world of pottery. She makes pottery that is as thin as bone ware and as that made by the old Indians. No one knows how she accomplishes this feat. Her folded rim cooking pots, a skill she learned from Nola Campbell, resemble pre-Columbian and Colonial pieces. She works constantly in clay and maintains a road sign on Indian Trail where she lives. Cheryl, a potter to watch, has only three rivals for the spot as the great Catawba potter of the 21st century.

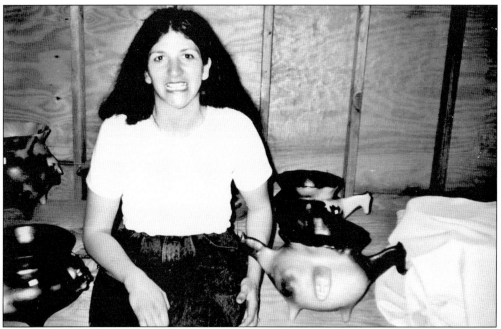

Margaret Robbins is following in the footsteps of her famous parents, Viola and Earl Robbins. She is possibly the most innovative of contemporary potters. She is also popular with museums and attends a huge number of historical fairs and craft shows. She makes an alternative to the Indian Head pot or the King Haigler Pot and calls it the Viola Robbins Pot in honor of her mom. She is a potter to watch and has only three rivals for the spot as the great Catawba potter of the 21st century. (Courtesy of Earl Robbins.)

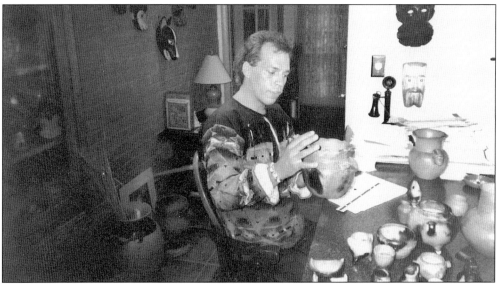

William (Monty) Branham is one of the finest potters in today's Catawba Indian Nation. In 1995, he took part in the Smithsonian Folk Life Festival on the Mall in Washington, D.C. He is also a noted flute player and has conducted workshops on making and playing the flute. He was a leader in the revival of drumming and dancing among the men. Monty is a potter to watch and has only three rivals for the spot as the great Catawba potter of the 21st century.

Mildred Blue (1922–1997) had a short but dramatic career as a Catawba potter. For many years, she assisted her mother, Doris Blue, in making pottery. Not until her mother's death in 1985 did Mildred begin to make on her own. During this period, Brian Blue found an old turtle pipe while digging a garage foundation. Mildred and other potters saw the form, and all were interested. This caused a great revival of the turtle pipe shape, and Mildred led the way. She made turtle pipes, turtle pots, and even turtle earrings.

Marcus Sanders is more than a rising star among the Catawba master potters. He grew up watching his grandmother Arzada Sanders working in clay. He began working independently in the 1980s. Today he divides his time between working as an electrical engineer and making walking sticks with burned Catawba designs, arrows, and a fine line of pottery dominated by the swan. He is a potter to watch.

Edwin Campbell, the son of Nola Campbell, is the undisputed master of the miniature. He started working in clay in 1991 during a period of great illness. He obtained a teacup full of clay from his mother and produced masterpieces that rivaled those of Nola in their grace. All are made by traditional Catawba building techniques and all could be used if they were larger. His peace pipes are a wonder to behold. His pottery resembles that of his mom but not in size, for Edwin's work is seldom over two inches in height.

Caroleen (Carol) Sanders is a master potter of tremendous skill. Her snake pots rival those of Susannah Owl. The reptile seems to be one of her favorite subjects, and she concentrates on turtles, lizards, alligators, and snakes. Her effigies often approach realism. She has been affiliated with the North Carolina Pottery Center at Seagrove for several years and is a regular at the annual pottery sale at Hickory, North Carolina. Caroleen is a potter to watch and has only three rivals for the spot as the great Catawba potter of the 21st century.

Eight
THE CATAWBA INDIAN NATION PROGRESS

It is a fact that the Catawba General Council is one of the oldest governing bodies in the United States. In the 16th century when the Spanish arrived on the coast of what later came to be known South Carolina, they found large council houses. The Indians, both men and women, resorted to these buildings to handle all business that related to the entire tribe. Those who excelled in the General Council, both men and women, were given the rank of War Captain. The Catawba General Council still exists and by law must convene once in January and once in July.

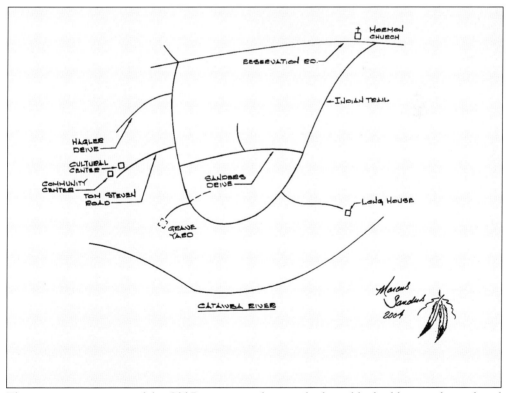

This contemporary map of the Old Reservation shows only the public buildings and sites found there. Though not shown here, the Senior Building is located across the parking lot from the Long House, on the Avenue of the Nations. (Map by Marcus Sanders.)

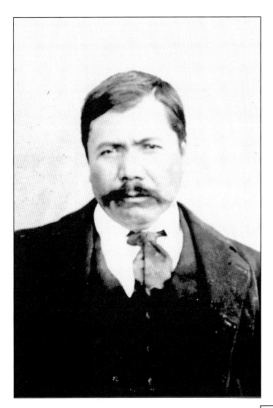

Chief James Harris was elected chief by the General Council in 1885, from c. 1892 to c. 1895, and for a short period in 1906. Under his leadership, the Catawba built their first school. Chief James Harris also initiated the suit against South Carolina and the federal government to see the Treaty of 1840 honored. This suit stayed alive without money or attorneys until the late 1970s, when the movement toward the Settlement of 1993 began. (Courtesy of the late Georgia Harris.)

Chief David Adam Harris (Toad), James Harris's brother, was elected chief by the General Council in 1907 and reigned until the scandal of his wife's death in 1917. He was elected chief again and was still chief until the mid-1920s. He died in 1930. This photo is of a plaster bust made early in the 20th century by the Smithsonian Institution.

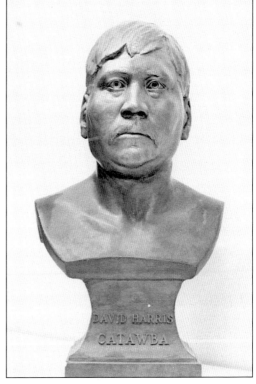

Chief Robert Lee Harris was chief for a short time in 1896. The General Council elected him again in 1941 for a two-year term. He ushered in the Federal Wardship. He traveled the road with Wild West shows and was a speaker of the Catawba language. He married Nettie Harris Owl and later married again and had one daughter Winona. Robert Harris was tribal historian. (Courtesy of the Smithsonian Institution, National Anthropological Archives.)

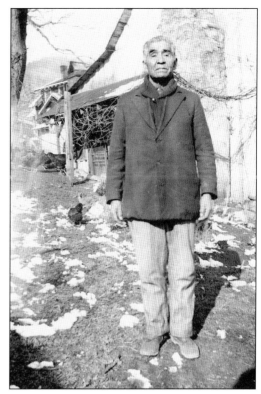

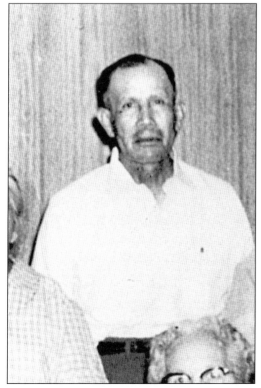

Chief John Idle Sanders was elected by the General Council for a short period in 1956. He was a traditionalist in spirit and helped the Traditionalist Faction, which still exists in the community. He frequently served on committees formed by the General Council and opposed the tribe's Termination in 1959. He was married to master potter Arzada Sanders. (Courtesy of the Bureau of Indian Affairs.)

After returning home from service in World War II, Chief Raymond Harris was elected chief by the General Council in 1946 and served until 1950. The son of Chief David A. Harris and Della George, he married Nola Harris and built the new Catawba Indian School. Harris was chief when many of the Indians obtained new housing; he died of cancer in 1952. His daughter Deborah Harris Crisco has taken up his interest in politics and is an active traditionalist. (Courtesy of Deborah Harris Crisco.)

Chief Douglas Harris was elected chief by the General Council in 1944 and reigned until 1946. It was a period when the Bureau of Indian Affairs was most active on the reservation, providing new land and new homes to the Indians. He was married to master potter Georgia Harris. His grandson is Chief Bill Harris. (Courtesy of the Bureau of Indian Affairs.)

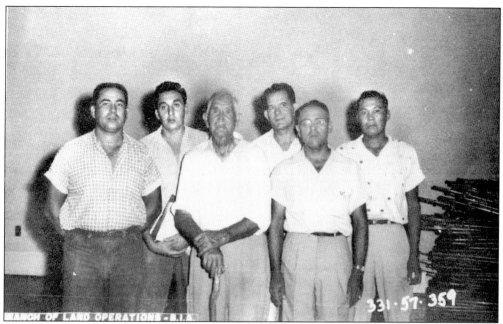

When the Bureau of Indian Affairs became involved in Catawba affairs, efforts were made to see that all was done by committee. The Land Operations Committee of 1957 oversaw all land issues. This committee was especially important as new lands were added to the reservation. Shown here are, from left to right, Big Gary Wade, Floyd Harris, Samuel T. Blue, Willie Campbell (non-Indian), Samuel Beck (founder of the Traditionalist Faction), and Hayward Canty. (Courtesy of the Bureau of Indian Affairs.)

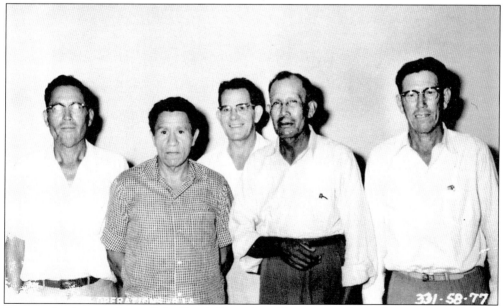

Apparently the members of the Land Operations Committee changed on an annual basis. This 1958 committee consisted of the following from left to right: Albert Sanders, Garfield Harris, an unidentified BIA officer, John Idle Sanders, and Willie Sanders. (Courtesy of Marcus Sanders.)

In the 1940s, the Bureau of Indian Affairs built an office on the reservation. This humble cinderblock building still stands and is used as a house by the family of Wesley and Reola Harris. By looking at this building, one can determine something of the BIA budget during the period. (Courtesy of the Bureau of Indian Affairs.)

Ellen Canty Bridges, shown here at a Yap Ye Iswa Festival, paints gourds. She also heads up all childcare facilities for the Nation. She often sells painted gourds at the Yap Ye Iswa Festival. Her brother Jackie Canty is assistant chief in the Chief William Harris administration. (Courtesy of Steve McKellar.)

Chief William Harris was elected chief by the General Council in September 2002. Chief Harris is the leader of the Traditionalist Faction and hopes to bring the tribe's government back to full financial accountability to the Catawba people. By profession, he is an artist working in the medium of wood. He is descended from Chief James Harris and Chief Douglas Harris.

Deborah Harris Crisco is a member of the Traditionalist Faction. She is disturbed that while the Catawba Bingo has brought in lots of money, little of it has gone into tribal programs as it should by federal law. In March 2004, a number of Catawba picketed the bingo parlor, and Deborah was one of them. Here she holds a sign dedicated to Claire Sanders Wilson, who helped plan the picket but did not live to see it materialize.

Roger Trimnal is a traditionalist and has supported this faction for many years. He was banned from a tribal meeting in 1994 for asking the wrong questions about finances. He was subsequently banned from the tribe, and his name was taken from the Catawba roll, an action that has no basis in Catawba law. Here he joins the bingo picket and asks the question regarding the legality of the bingo management's contract. He is the great-grandson of Chief Samuel T. Blue and the grandson of Chief Herbert Blue.

The Catawba Senior Center was opened in 2003. It offers a number of programs to senior tribal members and their spouses, including bus trips, lunch, and cultural programs, such as pottery building lessons from preparing the clay to burning the finished product. All of the programs offered by manager Joann George Bauer are well attended.

All of Catawba ire is not directed at current tribal politics. The Indians are interested in Indian issues nationwide. This bumper sticker placed on the rear bumper of Warren Brian Sanders's car speaks for Brian's concern. It is evident that Native Americans see that both the national and state governments have failed to work for their betterment.

All roads that lead to the reservation since 1993 have been carefully marked to help people find the Nation. This sign is placed at the reservation border so that visitors know they are in a jurisdiction other than York County, South Carolina.

One of the greatest contributions to reservation life made by the Chief Gilbert Blue administration is in the area of housing. Over 220 houses have been constructed since 1993, most by Housing and Urban Development. This house on World Changer Road is owned by Howard George. His totem pole can be seen in front of the house.

Once E. Fred Sanders became active again in the Traditionalist Faction, he began to paint signs and place them in his front yard on Reservation Road. Even those Indians who did not agree with his stand found the signs informative. The signs have served to keep the Traditionalist Faction alive and serve as a tribal memory from 1960 to the present. Fred continues to paint signs.

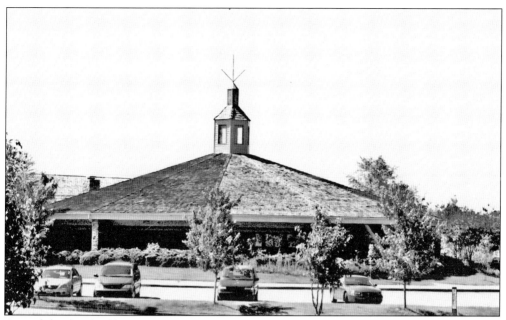

One of the first buildings constructed by the Blue administration following the Settlement of 1993 was the tribal Long House. It holds tribal offices and has a General Council room. The General Council has been barred from using this facility by the Blue Administration and for several years has resorted to tents and public building located in Rock Hill.

Red Path Baptist Church dates from 1997. It is located on Passmore Road at the edge of the reservation. Indian culture, including drumming and flute playing, is accepted as a vital part of worship, and Indian expressions have been worked into the service. This factor has drawn a number of younger Catawba who seek some voice for their Indian roots.

A fourth Mormon church was dedicated on March 16, 1986. It stands at the corner of Indian Trail and Reservation Road. The Mormons who came to assist the Catawba in the early 1880s built a powerful religious force that is still recognized by a majority of the church-going Indians. The church contains a sanctuary, classrooms, church offices, a baptismal room, nursery, a genealogy room equipped with computers, and a cultural hall.

Cheryl Harris Sanders is here with her grandson Kevin Leach-Hernandez, who was born on December 3, 2003, to Miranda Leach and Luis Hernandez. This child and other Catawba children are the hope of the future. It is certain that as soon as he can waddle around, his mother will have him dancing the Snake Dance. As soon as he can pat his hands, his grandmother will have him making something out of Catawba clay.

Nine

Catawba Indian Pottery

The Catawba Indian potters are only traditional potters living east of the Mississippi River. The Catawba for the most part learn from the elders within the family. They process two kinds of clay (pipe and pan) to make large vessels. Once a potter sits down to build pottery, at least 100 shapes are available to the potter. It takes years for a learning potter to master all these shapes. The vessel is built with simple tools: the hands, knives, stones, spoons, shells, carved coconut shell fragments, sticks, and other objects found about the house. Once the newly created vessel is dry enough, the pot is scraped with a knife and rubbed with an heirloom rubbing rock. Finished vessels are exposed to an open fire. As a rule three fires are burned over the pots. When fully burned, a good pot has a metallic ring.

Furman Harris digs clay for his sister Georgia Harris and his wife, Bertha George Harris. Here Furman is digging pipe clay, which is the base clay for all vessels. The clay holes are guarded from outsiders.

The Catawba potters have had problems accessing the traditional pan clay hole since Hurricane Hugo. The clay is extracted from a shallow cave. When the roof of the cave is judged in danger of falling in, a new hole is dug at the side of the cave. Here Larry Brown and Wayne George are taking clay from a newly dug hole. This clay is a grit, and it is used to give the newly constructed large vessels added strength.

Georgia Harris did not have a frame with window wire to strain her clay. Here she has built a temporary frame out of cut wood, lined the bottom with cloth and is straining her clay through an old piece of window wire. The water would leave the clay in two ways: through the cloth into the ground and by normal evaporation. When the clay is of the proper consistency, it is removed from the cloth basin.

Though nearly a century has passed since M.R. Harrington did his classical photos of the Browns working in clay, not much has changed. Georgia Harris is working on a lapboard. Newly constructed green ware rests on another lapboard. Georgia is kneading her clay much like bread dough to ensure that no air pockets remain in the clay. An air pocket will make the side of a vessel pop in the fire.

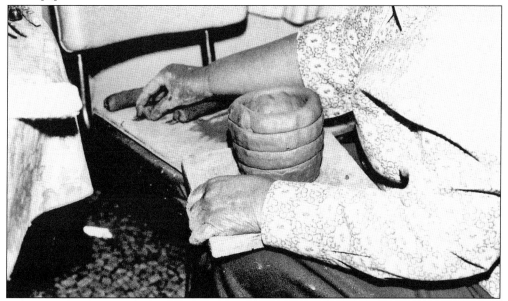

The Catawba construction methods have not changed for centuries. This photo is very similar to that of Rachel Brown at work in 1907. Georgia Harris is working on a lapboard, and she has built her vessel out of rolls. Additional rolls can be seen on another lapboard left on a kitchen chair to the left rear of the photograph.

Perhaps the most sought after and the most difficult vessel for the Catawba potters to make is the King Hagler pot. This one was made by the 19th-century master Martha Jane Harris. This vessel is in the Simpson Collection from Dr. William Simpson of Rock Hill. The Simpson family has generously placed Dr. Simpson's collection on loan to the Catawba Cultural Center.

The basic Catawba vessel from which a host of related vessels can be made is the ancient cooking pot. This pot has a lip and can be easily turned into a pot drum by tying an animal hide to the rim. The anonymous 19th-century masterpiece was collected by Dr. Simpson of Rock Hill.

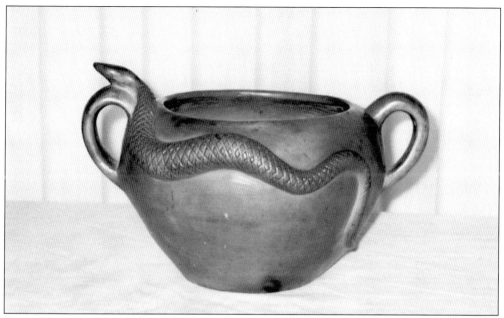

One of the most respected vessels any Catawba potter can make is the snake pot. Though the snake is applied to the side of the pot by an ancient construction method, if it is not done properly, it will pop off in the fire. This vessel is directly linked to the ancient and much-coveted rank of war captain. This snake pot is attributed to Susannah Harris Owl. (Courtesy of Melanie and Pat Zerance.)

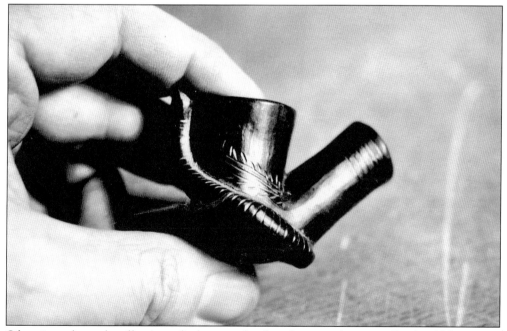

Oftentimes the snake effigy is applied to vessels other than a cooking pot. On this 19th-century masterpiece, a snake has been applied to a plain elbow pipe. The master potter who made this pipe was not recorded in the files of the Museum of the American Indian where this pipe was found. (Courtesy of the National Museum of the American Indian.)

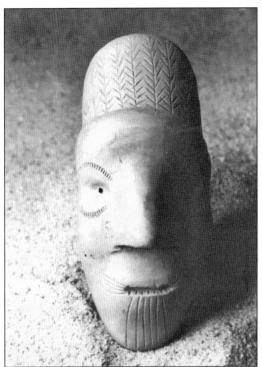

Many times the potters do not have a set of pipe molds and so make their own effigy heads. At times these may be termed "portrait pipes." This pipe was found in the Smithsonian's Catawba collection. The anonymous maker of the masterpiece chose to decorate the man's chin with a traditional tattoo motif. (Courtesy of the Smithsonian Museum of Natural History.)

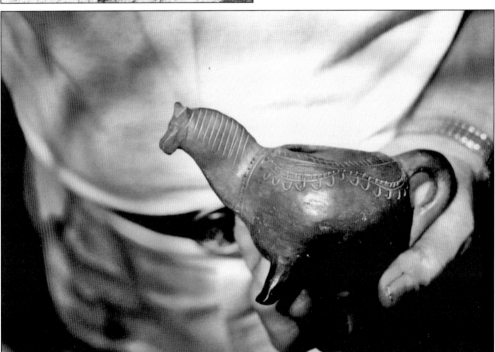

Billy Bowlegs Harris is remembered for his horse effigies. None has survived with his name on it. This horse effigy was preserved by the family of James White of Rock Hill. It may be the work of Billy Bowlegs. Today it is on loan to the Museum of York County. Of recent years, the horse pot has enjoyed a revival of interest among the Catawba potters.

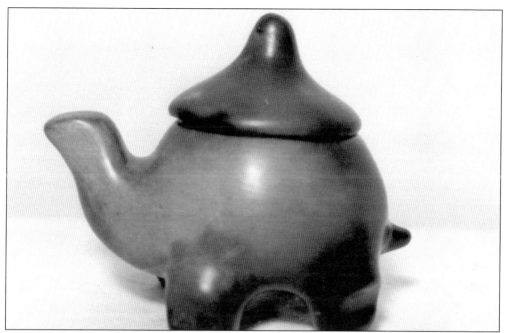

The turtle has long been a favorite subject for the Catawba potters. They produce an enormous number of turtle effigies, which are a certain sell. They also make turtle pipes and turtle pots. During the height of the North Carolina mountain trade, the potters produced turtle pencil holders and turtle ashtrays. This turtle pot was made by Louise Beck Bryson.

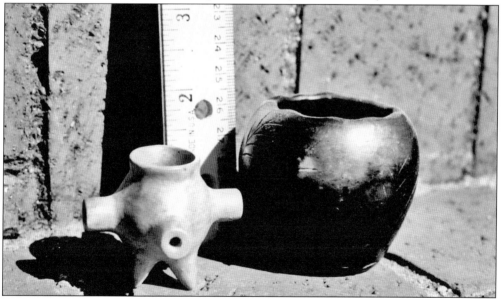

The Catawba have delighted in making miniature pots for untold centuries. Miniatures the size of a hickory nut are often found by archaeologists. We think the reason for such small vessels has always been the challenge. The peace pipe on the left was made by master potter Edwin Campbell, who only works in miniature. It is about an inch and a half tall and can be smoked. All of the appendages were inserted through the bowl using traditional methods. The small pot to the right was made by master potter Evelyn George.

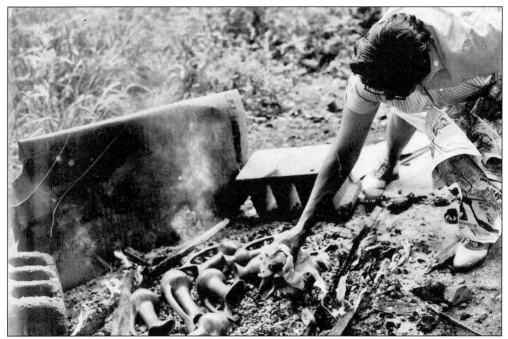

Arzada Brown Sanders, one of the most prolific master potters the 20th century produced, is taking traditional Rebecca pitchers from a fire. She has protected it from wind through the use of cinder blocks and a sheet of tin. If a sudden rain squall should come up, she would just take the tin and cover her fire and thus protect her work. (Courtesy of Marcus Sanders.)

The traditional Catawba potters stubbornly market their own work, usually from their homes. This is the best way to obtain a fair price, and it is the best way to find museum masterpieces, by pot hunting. This sign was created by master potter Cheryl Harris Sanders and her master potter husband, Warren Brian Sanders. They sell most of their work from their home and also attend historical festivals when the opportunity presents itself. This is the marketing method followed by most of the 75 adult potters in this Native American community.